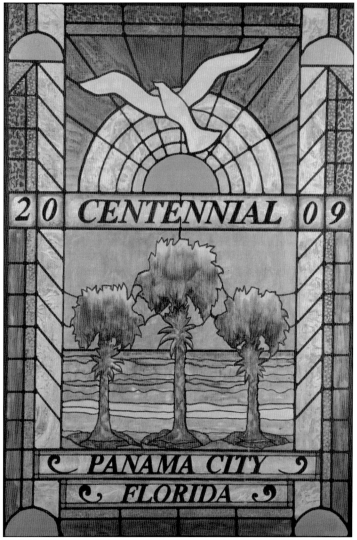

Artist Barbara Mulligan created this symbolic logo for Panama City's centennial. The format uses an art deco theme also used in the early development of the city. A sunrise shape has been placed in the four corners to represent the four communities that make up the city proper: the Downtown district, Millville, Glenwood, and St. Andrew. The top center shapes represent all four as one large sunrise surrounded by the four communities. A shorebird's upward flight connects the symbols. In the lower center, three sabal palms stand on the shore of St. Andrews Bay, representing the city's past, present, and future. The design's stained-glass pattern uses three dominant colors found in the area: blue, green, and golden brown. Touches of metallic gold over the painted surfaces create a glass look. The grey panels around the design incorporate ground oyster shell in the pigment. (Photograph courtesy of Barbara Mulligan.)

ON THE COVER: Josh Pollock is standing proudly beside his 1914 Ford. The car displays advertisements for several local businesses: Wilson's Furn-HDW. Undertaking, Dixie Mattress, Western Auto Assoc. Store, and Jackson-Chiles Cut-Rate Drugs. Proceeds from these advertisements may have helped this clever entrepreneur pay for his Ford. Possibly the car itself was also for hire as a taxi, but that can not be determined. (BCPL.)

IMAGES of America
PANAMA CITY

Glenda A. Walters

Copyright © 2008 by Glenda A. Walters
ISBN 978-0-7385-5352-8

Published by Arcadia Publishing
Charleston, South Carolina

Printed in the United States of America

Library of Congress Catalog Card Number: 2007937910

For all general information contact Arcadia Publishing at:
Telephone 843-853-2070
Fax 843-853-0044
E-mail sales@arcadiapublishing.com
For customer service and orders:
Toll-Free 1-888-313-2665

Visit us on the Internet at www.arcadiapublishing.com

Even at 100, Panama City is young enough that many members of its second or third generation still reside in the city. With pride, they operate the businesses, attend the churches, and maintain the homes established by their forefathers. Although this volume cannot feature each and every such family, it is dedicated to those settlers. May we always reflect on our rich history.

Contents

Acknowledgments 6

Introduction 7

1. Faces and Families 9
2. Hometown 37
3. Some Sights around Town 61
4. Community Spirit 91
5. Looking to the Future 115

Acknowledgments

Historical research is always rewarding, whether it is finding one old photograph in a box of discarded bills and receipts or one newspaper clipping that solves a mystery or creates a new one. For me, the search is as entertaining as a game of hide and seek is to a child, but true satisfaction comes when someone tells me "my sister is in that photo" or "I never knew about my father's business until I read your article." It is with this attitude that I approached this work on Panama City.

I have watched this little city undergo the same alterations that came to many other cities late in the last century. Panama City changed from a main-street downtown area bustling with shops, cafés, offices, banks, and a movie theater to a silent and deserted-looking place with empty buildings. It happened quietly while everyone celebrated the opening of the mall, soon followed by the discount stores on the outskirts of town. Shoppers changed their routine. Many small businesses were unable to compete and closed their doors. Neighborhoods looked forlorn as families moved to the suburbs.

Fortunately revitalization worked. Through the efforts of the Downtown Improvement Board, the Historical Society of Bay County, and dedicated citizens, downtown is back. Its return is celebrated with First Friday Fests, cultural festivals, and an ongoing program of theater and musical performances. I celebrate the birthday and rejuvenation of this Gulf Coast city by securing its place in Arcadia Publishing's Images of America series.

I want to express my gratitude to all those who made my research so rewarding. Special thanks are due to all those individuals willing to share family photographs and those who even went so far as to share their own research with me. Their generosity made my work easier and more accurate. I am also indebted to the numerous civic, religious, and community organizations for allowing me to search scrapbooks and storage bins for photographs and history. The enthusiastic support of the Historical Society of Bay County and the Panama City Centennial Committee has been inspirational. Above all, I am especially indebted to the assistance of Rebecca Saunders and her staff at the historical archives of the Northwest Regional Library.

Without the cooperation and support of all my family, none of my dreams or projects would be possible. Thanks to my husband, children, and grandchildren. Thanks!

AC	Author Collection	LFC	Lewis Family Collection
BCCC	Bay County Chamber of Commerce	LHC	Lyn Hindsman Collection
BCPL	Bay County Public Library	LTC	Libby Tunnell Collection
BFF	Byrd Family Foundation	NFC	Nelson Family Collection
DIB	Downtown Improvement Board	PCGC	Panama City Garden Club
FBC	First Baptist Church of Panama City	PCWC	Panama City Woman's Club
FPC	First Presbyterian Church	RJC	Ralph J. Conrad
GCCC	Gulf Coast Community College	SFC	Spiva Family Collection
GFC	Gray Family Collection	SLC	Sue Lee Collection
HFA	Hutchison Family Archives	WAC	Willard Anderson Collection
HFC	Hobbs Family Collection	WSC	William Stevenson Collection

INTRODUCTION

Panama City, Florida, lies along St. Andrews Bay in the northwest Florida Panhandle, approximately 100 miles east of Pensacola. In the early 1800s, settlements existed along the shores of this bay. During the Civil War, salt for the Confederacy was produced on the shoreline, and one skirmish was fought within the present city limits of Panama City. In 1884, the U.S. government deeded a large tract of land along the bay to Samuel J. Ervin. The land changed hands again in April 1887. The new owner was Capt. George W. Jenks, who sold a portion of the property to C. J. Demorest, a Union army veteran from Rochester, New York. Together the two settlers platted their land as Park Resort. There Jenks erected a hotel, and Demorest built a store, which he operated himself. The two sold only a few lots in Park Resort along the waterfront and inland three or four blocks. In 1889, during the presidency of Benjamin Harrison, the town acquired a post office. The settlers living there renamed the town "Harrison" to honor the president. Unfortunately the anticipated town did not develop because the boom of the 1880s ended with the depression of 1893. However, Jenks and Demorest were not the only men to see potential in the area.

George West, a lawyer, railroad executive, and newspaper publisher, shared the vision of his predecessors. Considered the founder of Panama City, the Chicago businessman became a vacation-home owner in 1887. By 1902, he became convinced that it was time to begin developing the area. With two other stockholders, he organized the Gulf Coast Development Company in May 1905. The company opened an office on the waterfront and bought vast tracts of land in and around the town of Harrison. He became a Florida resident and purchased a house on St. Andrews Bay. West is probably best remembered for his St. Andrews Bay Publishing Company, where he began publication of several newspapers, including the *Panama City Pilot*. Other business ventures included the first bank and later the telephone company.

Other men of vision also played important roles in the establishment of the city. R. L. McKenzie secured the right-of-way for rail lines, and A. B. Steel of Atlanta was instrumental in constructing the railroad from Dothan to the coast. On June 29, 1908, the *Panama City Pilot* reported that the first train, filled with "well-wishers and sightseers," rolled into Harrison. Steel also established a steamship line to develop connections to other ports on the Gulf. A. J. Gay also worked to bring the railroad to the area and served on the board of directors for the bank. He built the first steam-powered lumber mill in the area and produced the first turpentine shipped to market. Active in the chartering of Panama City, Gay was elected president of the city's first town council.

In February 1909, a notice of intent to incorporate the town was announced, and the legal documents were drawn. When required elections were held, R. L. McKenzie, vice president of the Gulf Coast Development Company, was unanimously elected the first mayor. He was on the bank's board of directors and had traveled the country to interest investors and railroad executives in northwest Florida. McKenzie also served in the Florida House of Representatives in the 1909 and 1911 sessions.

At the time of incorporation, there were about 434 registered voters in Harrison. George West is credited with naming the new town. The intention was to emphasize Panama City as a potential port on the Gulf Coast for ships that would pass through the Panama Canal. The town's charter was granted on February 23, 1909.

Through the years, Panama City grew despite its struggle to establish railroad and port connections to major cities. Timber and turpentine were its major industries, but fishing and boat building provided employment for many. Businesses opened along the waterfront to accommodate both residents and visitors. A. L. Williams built the first ice plant in 1911 and provided home delivery. The Crawford family built the Gulf View Inn. A bottling plant, a car dealership, and a drugstore followed. Sea launch excursions around the bay, recreational fishing, and a peaceful lifestyle attracted tourists to the area, and a number of hotels and apartments opened to accommodate them.

In 1930, International Paper Company built the first pulp and paper mill in Florida in the Millville section and carried the community through the Great Depression. World War II forever changed the face of Florida and Panama City. Construction of Tyndall Field began in early 1941, and the facility was dedicated the day before Pearl Harbor was attacked. The mission of Tyndall Field was to train flexible gunnery skills in the BT-13, a single-engine trainer. On April 7, 1942, the J. A. Jones Company of Charlotte, North Carolina, signed a contract to build a shipyard at Panama City, Florida, and produce Liberty ships for the military. By July 1944, fifty ships had been launched from Wainwright shipyard. Hundreds of workers, particularly women and older men, contributed to the war effort and earned good wages there. The navy commissioned a site on St. Andrews Bay as a section base in the 8th Naval District on April 22, 1943. Its officers were responsible for the operation, administration, and maintenance of inshore patrol vessels assigned to the base; for making the facilities of the base available to other operating forces; and for carrying out the training program for assigned personnel.

At the conclusion of the war, Florida and this area prospered with the return of servicemen who chose to make it their home in peacetime. The shipyard closed in 1946, but the air force and navy presence remained. As equipment returned from overseas, maintenance workers at Tyndall repaired it, and civil service workers were hired to operate the base. Tyndall Field was expanded to a full military base and renamed Tyndall Air Force Base in 1947. The naval station became a permanent research facility specializing in undersea technology. Today both employ a large civilian work force and contribute millions of dollars to the community as employers.

A goal of Panama City residents was realized when Gulf Coast Community College opened on September 17, 1957. Later Florida State University's branch campus provided higher educational opportunities. During the 1960s, a new civic center and marina were built at the foot of Harrison Avenue. However, Panama City began to grow in areas outside the traditional downtown. Businesses began to expand and relocate on Fifteenth Street, where the first large shopping center, Panama Plaza, opened in 1962. It featured two grocery supermarkets, the W. T. Grant department store, and several smaller shops. The Forest Park and Northshore subdivisions provided homes for the growing population. In 1976, the Panama City Mall opened at the intersection of Highways 231 and 77. Twenty-third Street replaced Fifteenth Street as the busiest business corridor. Growth continues to push Panama City's northern boundaries, and as a new century begins, there seems to be more prosperity ahead.

The pictures in this book follow the scenes and personalities of Panama City through 100 years. They are intended to rekindle memories. May those memories and recollections be pleasant ones.

One

FACES AND FAMILIES

In the summer of 1907, Capt. Harry Felix recorded his first impressions of what was then called Harrison when he and his wife sailed their sloop *Jolly Rover* in from St. Andrews Bay. "Finally arriving there, we proceeded up what is now called Harrison Avenue. Could not see much of it on account of the trees. . . . There were only fourteen adults living there then and they could be seen collectively on Wednesdays and Fridays when the steamer *Tarpon* blew her whistle. At that time she landed on the city dock at the foot of Harrison presently all the fourteen would appear out of the woods and if any were absent, anxious inquiries would be made." According to Captain Felix, the inhabitants of Panama City at that time consisted of George McKenzie (general-store operator), Robert McKenzie (turpentine business), Mr. Goodson (bookkeeper for A. J. Gay), Mr. McClellan (pilot and printer), H. T. Hogeboom and wife, H. T. Hogeboom Sr. and wife (hotel operators), John Ward (sawmill), Mr. Poston (postmaster), Marion Jenks, Mr. Dykes and wife, Mrs. Walter Green (hotel worker).

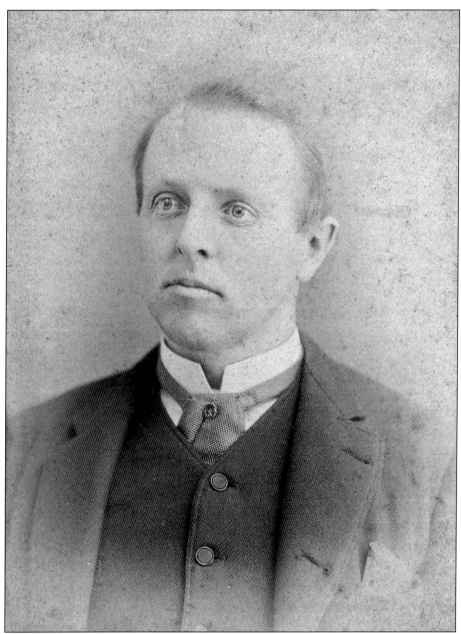

George West is recognized as the "Father of Panama City." A property owner as early as 1887, the *Pilot* said he became convinced by 1902 that the time had come "when something could be done toward developing the magnificent natural deep water harbor of St. Andrews Bay and the adjacent country." He worked tirelessly with other dedicated citizens to bring the railroad to the bay and was also instrumental in the chartering of the city in 1909. He began publication of the area's first newspaper, the *Panama City Pilot*, in 1906 and served as its editor for the next 20 years. Other feats to his credit include organization of the first school, bank, and telephone company. Upon his death in 1926, he was memorialized with these words in the *Pilot*: "a loyal and energetic supporter of every movement inaugurated for the betterment of Panama City and the St. Andrews Bay County and all West Florida." (BCPL.)

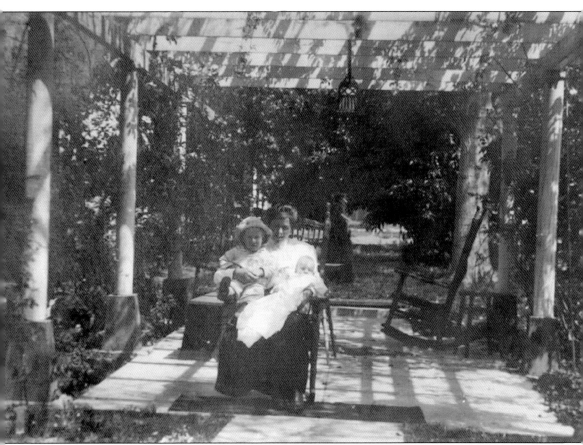

Lillian Carlisle West, known also as "L. C. West" in the business world, was the wife of George M. West. She was born in Troy, Alabama, and as a child came to the bay area when her father retired from his law practice. She was raised in the Millville community. At the age of 24, she asked the widower George West to allow her to write a column in his newspaper promoting the creation of the East Bay canal. In 1909, she became his third wife, and in 1915, the canal was a reality. Before George West died in 1926, Lillian was managing many of his business interests and newspapers. In 1923, she was the owner, publisher, and business manager of the *Pilot*. A woman of strong convictions, Lillian West developed her own editorial style. She was the first woman to register to vote in the St. Andrews precinct. (BCPL.)

A little frame building at the foot of Harrison Avenue was one of the first few structures in Panama City (Harrison). As the signs boldly state, it was the office of the Gulf Coast Development Company, organized by George M. West. In 1906, Mary B. Jenks, W. F. Look, R. L. McKenzie, Julia C. Mason, Peter G. Fallon, and E. N. Senneff became stockholders in the venture. (BCPL.)

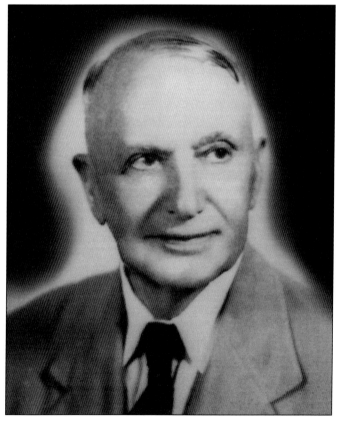

W. F. Look was a stockholder in the Gulf Coast Development Company. Active in the community, he was elected mayor in 1911. He was later compelled to resign because it was illegal for the mayor to work for a company doing business with the city. Look was also president of the chamber of commerce in 1928–1929. Mayor W. F. Look presided over the ground-breaking ceremonies for Panama City High School in 1913. (BCCC.)

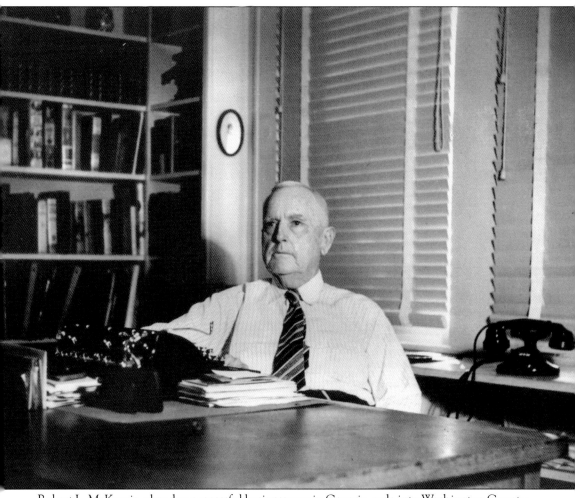

Robert L. McKenzie, already a successful businessman in Georgia, rode into Washington County in 1902 on horseback bringing a crew of turpentine workers with him. He was impressed by the beauty of the shoreline and envisioned a pleasant and prosperous town. McKenzie continued in the naval stores business and launched his Florida career as a partner in the Vickers and McKenzie turpentine still, located north of Millville. In 1904, he joined George West in the Gulf Coast Development Company and became its vice president for the next 10 years. He was a director and stockholder in the Birmingham, Columbus, and St. Andrews Bay Railroad. He was active in organizing the First Bank of Panama City, where he was a board member and cashier. On February 23, 1909, Robert McKenzie was elected Panama City's first mayor. He served for the next two years and signed the first 31 ordinances. He also served as a representative in the 1909 and 1911 Florida legislative sessions. In 1913, the newly formed Panama City Chamber of Commerce elected him its first president, and that same year, Gov. Albert W. Gilchrist appointed McKenzie St. Andrews Bay's first harbormaster. (BCPL.)

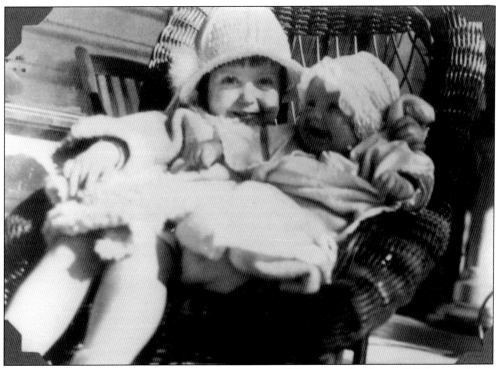

The young daughters of Robert and Blandford McKenzie are seen sharing a child's wicker chair, which still sits upstairs in the bride's room at McKenzie House. Big sister Anne is on the right, and baby Ellen snuggles close. The girls are bundled against the chill of winter in 1924 or 1925. (BCPL.)

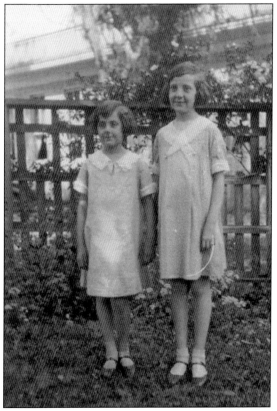

The McKenzie daughters are standing in the yard of their family home. On the right is Anne McKenzie Morten, who became an accomplished musician. She worked at Tyndall Field during World War II and shared her talent by playing for religious services on the base. Her little sister, Ellen McKenzie Tutte, is on the left. All accounts indicate that the house was always full with friends and family. (BCPL.)

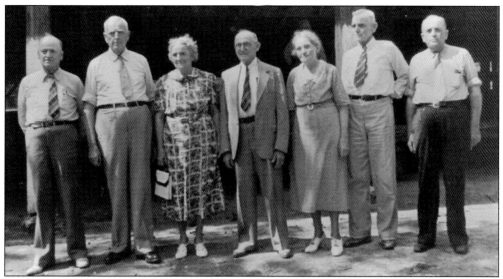

Always a close family, this photograph records a reunion of the McKenzie siblings around 1940 in Oglethorpe, Georgia. Pictured from left to right are William Columbus McKenzie, Robert Lee McKenzie, Clara McKenzie Taylor, Carlton M. McKenzie, Hester McKenzie Perry, James Edgar McKenzie, Oscar McKenzie. (BCPL.)

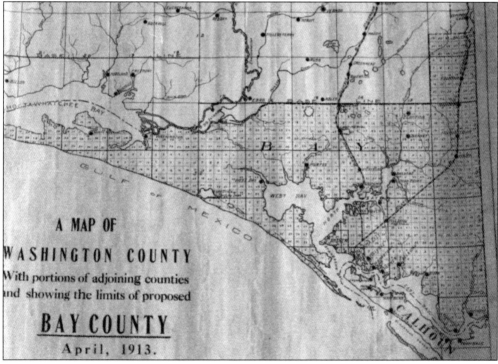

In 1913, most of Bay County's land was located in Washington County. As Panama City developed and grew along with other St. Andrews Bay communities, it became more and more of a challenge for legal documents to be recorded or official business to be conducted in Vernon, the county seat. It took a full day to get to there and another to return. The Florida legislature created Bay County on April 24, 1913. George West is credited with naming the county. (BCPL.)

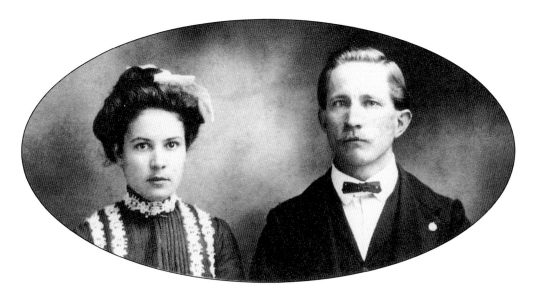

Lewis Henry Howell is shown with his lovely wife, Eula. The couple occupied a house on Olive Street (later Second Place). He represented Washington County in the state legislature in 1913. Howell introduced a bill to create a new county from southern Washington County. Robert McKenzie and Judge J. R. Wells went to Tallahassee on the day the bill came up for a vote and requested the leader of the bill's opposition to meet with them and tour the city. By the time they returned, the vote had been taken, and Florida's 49th county was a reality. (HFC.)

Nellie Howell Hobbs, the third child of Lewis and Eula Howell, was born in the family home on Second Place. After attending Bay County High School, Nellie eloped with George W. Hobbs. Together they raised two daughters and a son. He was the owner of City Iron Works and also served as a Bay County commissioner from District 4. Nellie was active in community affairs, particularly the Panama City Woman's Club and the First United Methodist Church. (HFC.)

By Messrs. Sudduth and Gray of Bay

HOUSE RESOLUTION NO. 41

"IN MEMORY OF LEWIS HENRY HOWELL"

WHEREAS, our Gracious Savior has called unto his reward, Lewis Henry Howell, of Panama City, Florida, a former member of the House of Representatives of the State of Florida, who was a member of the House of Representatives in the Session in 1913, representing Bay County, and was prior to that time, Treasurer of Washington County, Florida, for two terms, 1902-1905, and was Mayor of Panama City, Florida, from 1915 to 1917, and was a member of the Senate in the Sessions of 1929 and 1931, representing the Twenty-fifth Senatorial District, and

Whereas, Lewis Henry Howell was Representative from Bay County at the time Bay County was created, and was a leader in Bay County and West Florida in all civic and political affairs of his section of the State for many years, being one of the pioneer developers of Bay and Washington Counties, Florida, who set an example of unselfish and faithful service and untiring efforts to advance the cause of right and progress at all times;

NOW, THEREFORE, BE IT RESOLVED by the House of Representatives of the State of Florida that this State has lost a faithful servant and helpful friend, and BE IT FURTHER RESOLVED that this resolution be printed in the Journal of the House of Representatives as a token of the State's appreciation of his work, and that a copy of this resolution under the Great Seal of the State of Florida be furnished to the members of his family.

This resolution published in the journal of the Florida House of Representatives pays tribute to Lewis Henry Howell. A copy was presented to his family. It recounts his accomplishments in government and honors his years of service to Florida. (HFC.)

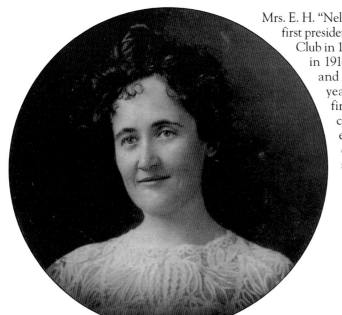

Mrs. E. H. "Nellie" Wilkerson was not only the first president of the Panama City Woman's Club in 1913 but was also president again in 1916–1917, 1923–1924, 1926–1927, and 1934–1937. She served eight years as president, six years as first vice president, two years as corresponding secretary, and eight years as a director, a total of 24 years of service as an officer and director. (PCWC.)

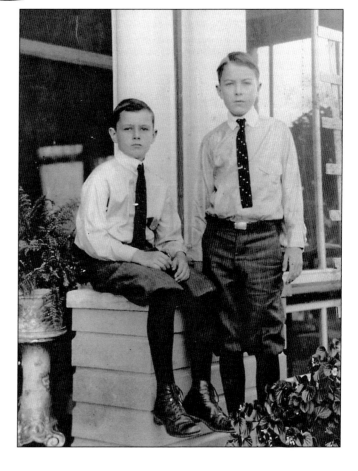

The two young men pictured here are the sons of Joshua M. and Ella Mae Sapp. On the right is Herbert Patton Sapp, born in 1910, and on the left is William Howard Sapp, born in 1912. Their father was a very prominent Bay County attorney and later a county judge. Both young men became attorneys and joined their father in practice. (BCPL.)

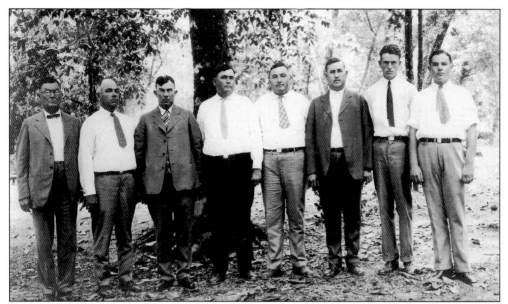

While attending a Hobbs family reunion, G. W. "Papa" Hobbs was photographed with his seven sons. Pictured from left to right are Walter, who was in the turpentine business; O. E., who was Bay County's sheriff for 13 years during the 1920s and 1930s; Wesley, who worked in turpentine and boats; Emory, career unknown; Carl, also in turpentine business; and John and Russell, who both worked at the paper mill. Between the birth of Carl and John, three daughters were born into the Hobbs family. (HFC.)

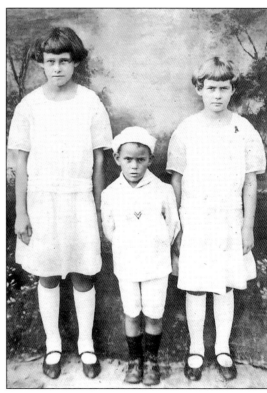

Estell (left), George (center), and Louise Hobbs, pictured here, were the children of George Wesley and Mary Francis Hobbs and the grandchildren of G. W. "Papa" Hobbs. A fourth child, Gladys, does not appear in this picture. (HFC.)

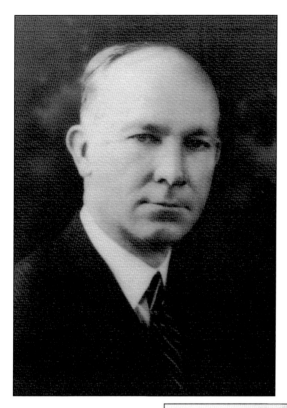

Ira Hutchison was an important factor in Panama City's early history. A graduate of Stetson Law School, he drafted the documents of incorporation for the city in 1908–1909. He served as a state attorney, a judge in the 27th Circuit, and assistant attorney general of Florida. He held the position of 14th Circuit judge until his retirement in 1947. His keen interest in local history led him to write *Some Who Passed this Way* as well a weekly column in the local newspaper. (HFC.)

Theodora Hutchison, a graduate of Montevallo College, married Ira Hutchison in 1907. She too was active in the civic life of Panama City. As president of the Panama City Woman's Club in 1940, her goal was a library for Panama City. She told the membership "you will be surprised how much you can collect in one afternoon." Hutchison was active in the Colonial Dames, the DAR, and the UDC. She also enjoyed writing poetry. (PCWC.)

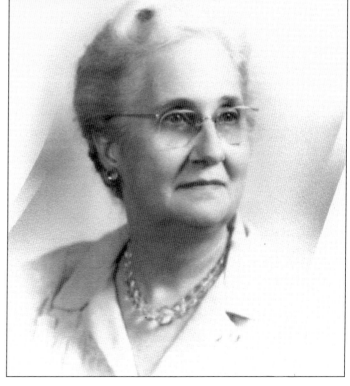

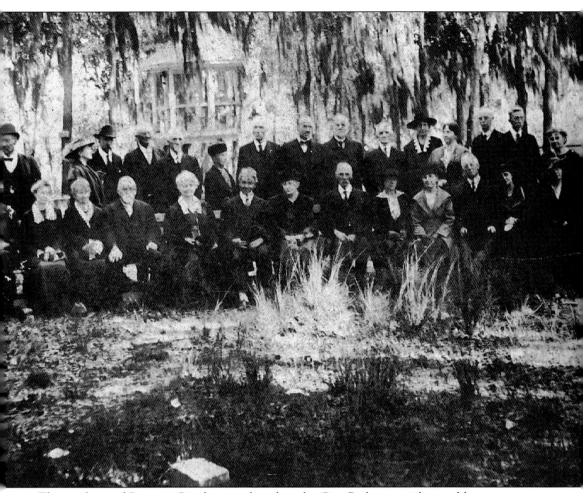

The residents of Panama City have gathered in the City Park to socialize and have a group photograph taken. Notice the gazebo in the background. This park, located on block east of Harrison Avenue, has been the scene of many celebrations, concerts, and community events since Panama City's beginning. On December 8, 1964, the park was renamed McKenzie Park in honor of R. L. McKenzie's devoted service to the community. It continues to be the heart of downtown events. Today those pictured are recognized as the city's pioneers, but they no doubt saw themselves in terms of the future. Although the individuals are not identified, one can imagine that those 14 named in Captain Felix's journal are present. In the early 1940s, Judge Ira Hutchinson established the tradition of an annual pioneer gathering and hosted it at his home for many years. Today the Historical Society of Bay County hosts the annual Pioneer Picnic. (BCPL.)

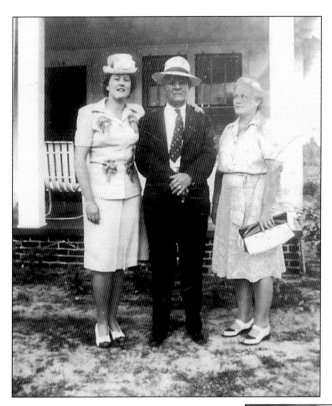

Dr. A. W. Lee poses with his daughter, Ruby (left), and his wife, Rosa (right), in 1945. Ruby had just returned home to Panama City after serving as a nurse in World War II. She later owned and operated a beauty salon in town. (SLC.)

Ammie Leonard Lee came to Panama City in 1913 and opened a jewelry store. He married Rosa Burdette in 1916. Lee repaired timepieces and sold rings, but the town needed an eye-care specialist, so he went to optical school in Topeka, Kansas. When he returned, his shop repaired watches, sold glasses, and offered eye examinations. Dr. Lee provided eye care for residents for the next 50 years. He and his grandson, Joe, stand on the porch of his home on Grace Avenue. (SLC.)

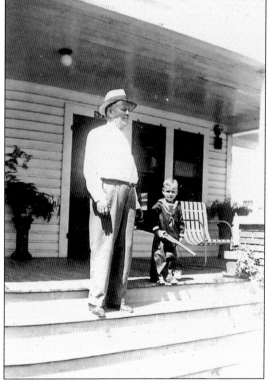

Walter Colquitt Sherman owned a lumber mill with Minor Keith north of the bay and the Atlanta–St. Andrews Bay Railroad Company. In 1919, they purchased the German American Lumber Company and made it the headquarters of the St. Andrews Bay Lumber Company. Sherman functioned as its executive vice president and was also a director of the First National Bank, a founder of the Panama Country Club golf course in 1927, and a supporter of Panama City baseball club in the 1930s. He and his family lived in a Spanish-style home in the Cove area and were the leaders of Panama City society. (BCCC.)

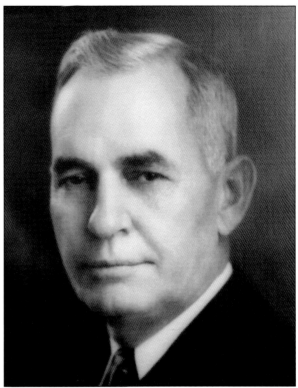

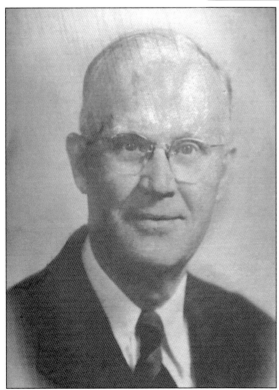

After a long and arduous journey that brought him from a little Greek village in Turkey to New York to Jacksonville, to Tarpon Springs and to Quincy, John Christo Sr. made his home in Panama City, Florida. He worked in restaurants in each of these cities, but in Quincy, he decided he would like to operate a store like the McCrory's dime store. John Christo Sr. was the founder of Christo's .05, .10, .25, $1.00 Stores. Eventually, he owned 42 stores with administrative offices and a warehouse on Grace Avenue in Panama City. Each of the stores displayed this 1951 portrait of John Christo Sr. (BCPL.)

In this 1932 photograph are members of the Spiva family. Seen from left to right are great-grandma Harriett Taylor Spiva, Betty Sue Spiva, William E. Spiva, and Ernest R. Spiva Sr. William became captain of the St. Andrews Bay Pilots' Association in 1908. He served as a bar pilot until his death in 1933. His son, Ernest Sr., received his license from the U.S. Coast Guard and became a bar pilot in 1932. He retired 42 years later. (SFC.)

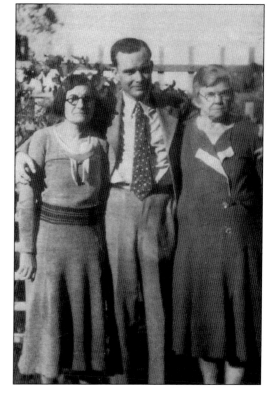

Another generation of the Spiva family is recorded on film. From left to right are great aunt Irene Spiva Brown, Ernest R. Spiva Jr., and grandmother Mollie Brown Spiva. Now retired, Ernest Jr. was a longtime Bay County educator and principal of Rutherford High School. (SFC.)

Frank McGill Nelson Sr. is pictured here. He and his wife, Helena Olivia Appelberg Nelson, moved to Bay County in 1912. He first worked as a sawmill in Southport. Later he opened the first Buick agency in the county. In addition to operating the car dealership, he was superintendent of the St. Andrews Bay Lumber Company in Millville. He was also sheriff from 1915 to 1917 and represented Bay County in the Florida Legislature from 1917 to 1919. From 1923 to 1935, Nelson Sr. served as mayor of Panama City. He died in 1937 at the age of 49. The bridge over Massalina Bayou at Tarpon Docks was later named in his honor. (NFC.)

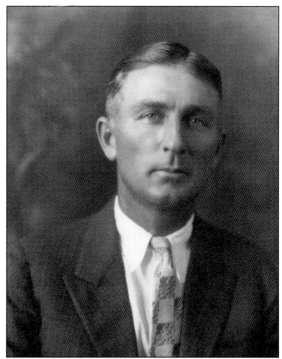

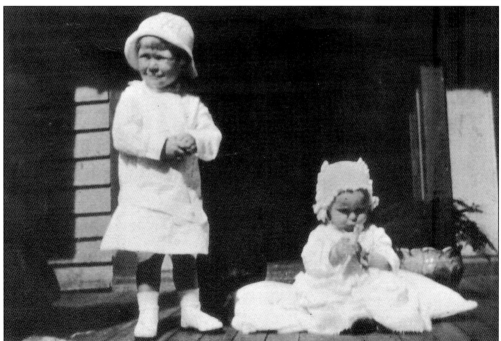

The two sons of Frank M. Nelson play together around 1914. Standing is Frank Jr., and seated is Marion ("Bubber"). Both little boys grew up to become respected businessmen, community leaders, and philanthropists. Frank Sr. and Frank Jr. were the first father and son to both serve as mayor of Panama City. Bubber operated the Buick dealership after his father's death and was also president of the Commercial Bank. (NFC.)

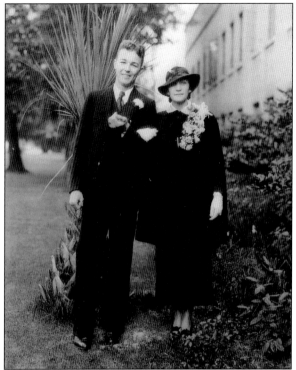

Marion and Barbara Wing Nelson pose on the grounds of the old Cove Hotel after their wedding in January 1935. The wedding ceremony was held at Wallace Memorial Presbyterian Church. At that time, the church was located in the old school building that had been moved to Harrison Avenue. In 1985, the Nelsons celebrated their golden wedding anniversary. (NFC.)

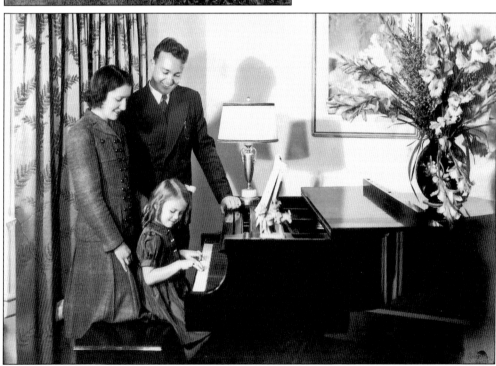

Standing beside the baby grand piano in the living room of the Harry Fannin home, M. G. "Bubber" and wife Bobby Nelson enjoy daughter Gretchen's music. The decor of the home is typical of the style popular in the late 1930s and early 1940s. (NFC.)

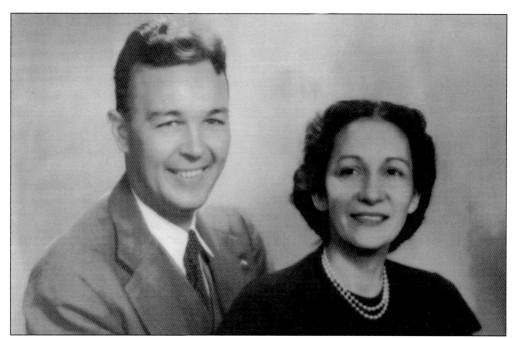

Bubber Nelson and his wife influenced their community in many ways. She was active in women's organizations and the Wallace Memorial Presbyterian Church. Bubber Nelson graduated from Bay High School in 1931 and took over his father's automobile dealership when Nelson Sr. died in 1936. He later became president of Commercial Bank and was elected director of the Southern Company. He was president of the Panama City Chamber of Commerce in 1944 and served on numerous state committees representing the area. (NFC.)

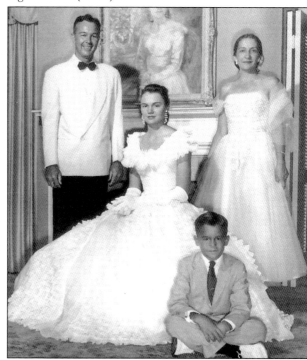

An elegant family portrait of the Nelson family was used on this Christmas card. The portrait over the fireplace in the background is of Bobby Nelson. The family members signed the card "Bobby and Marion, Gretchen and Bubber." The children are seated. (NFC.)

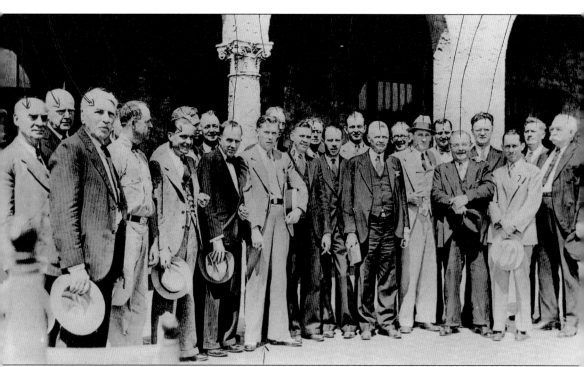

This group of businessmen standing in front to the Dixie Sherman Hotel is truly the foundation of the entire city at the time the photograph was taken. They represent the fields of law, politics, and medicine. A number of the area's developers are also among their ranks. Although not dated, it was most likely taken in the mid-1930s. Most who are facing forward can be identified. From left to right are Frank Nelson Sr., R. L. McKenzie, H. H. Cotton, Grover Rodgers, Ernest Spiva, Dr. J. M. Nixon (head aside), Jimmie Smith, Waldo Wallace, Doc Daffin, Judge Ira Hutchison (in background), two unidentified, Philip Roll, Curtis McCall, J. D. Sellars, Fred Philips, ? Reis, A. M. Lewis, L. E. Merriam, G. A. Fellows, H. L. Sudduth, and A. P. Drummond. (NFC.)

William B. Gray was owner of Gray Lumber Company in Springfield. Gray was responsible for platting an unincorporated section of land north and east of Panama City. He called a meeting of area residents, who drew up the charter for a new town to be called Springfield. The legislature passed the request in 1935, and thus Gray became the "Father of Springfield." Active in Panama City business, he and his family lived on Harrison Avenue. (GFC.)

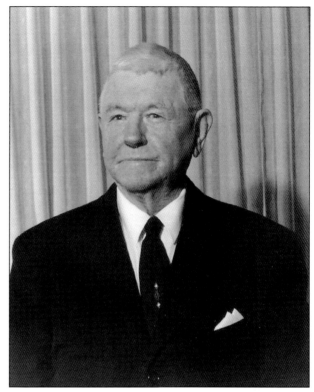

Pictured is the family of William Benjamin Gray, a Panama City businessman. From left to right are Mae Gray Asbell, W. B. Gray, Marjorie Gray March, R. Hosea Gray, Idumea Gray Marshall, J. Sylvester Gray, and Lelia Gray Hunter. The siblings are gathered to celebrate the birthday of Hosea. (GFC.)

James R. Asbell would certainly be included in any roster of Panama City's founding fathers. He moved to North Florida from Cairo, Georgia, as a young man of 20. Asbell became the first building inspector in Panama City, reportedly for the sum of $100 per month. He established the J. R. Asbell Concrete Block Company and was also a builder. He supervised the construction of the Bay County Court House, the city hall, Bay County High School, and St. Andrews Elementary School. Between 1932 and 1936, he served on the state road board; between 1946 and 1948, he was mayor of Panama City. Because he was most generous with his resources to many civic, religious, and educational causes, the business department building at Gulf Coast Community College is named in his honor. Pictured below is Mae Gray Asbell, sister of William Gray. She was active in the woman's club and other civic groups but is also remembered for her abilities as a bridge player. (GFC.)

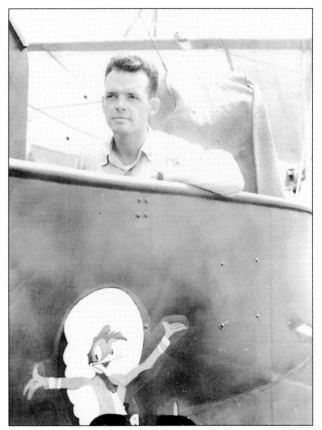

David Gray is shown here aboard the U.S. Coast Guard patrol boat on which he served during World War II. At the conclusion of the war, he returned to Panama City, where he joined his father, Willie, and brother, Leonard, in the family business, Gray Lumber Company. He served the community in a number of organizations and positions. He was on the board of trustees at Gulf Coast Community College and the boards of directors for the Bay National Bank and Bay Memorial Hospital. (GFC.)

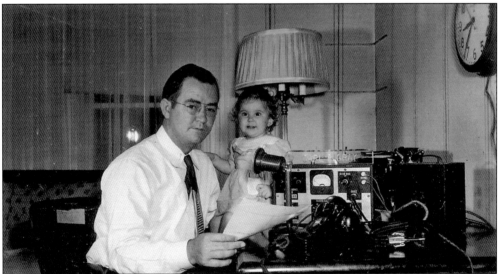

Carl Gray, son of Hosea Gray, was active in many phases of Panama City life. Although he served as mayor, he is best remembered for what he is doing in this picture: reporting the local noon news for radio station WDLP. Here he makes that broadcast from his home as his young daughter looks on. He always closed his news broadcast with the admonition, "If you don't want to make the news, don't do it." (GFC.)

Wyatt Oates Byrd was a probate judge of Coffee County, Alabama, for 18 years before opening a bottling business in Enterprise, Alabama. He bought a citrus grove in Texas, but three freezes the first winter wiped out the grove, so in 1930, he moved to Panama City with his wife and 12-year-old son, Isaac. He established the NeHi Bottling Company, which later became the Byrd and Son Bottling Company. Byrd was active in the business until his death in 1952. (BFF.)

Olivia Reid married Wyatt Byrd in 1915 in Enterprise, Alabama. When they moved to Panama City in 1930, she joined the First Baptist Church on her first Sunday in town. She taught Sunday school and was president of the Women's Missionary Union for nine years. She was a lifetime member of the woman's club and a charter member of the St. Andrews chapter of the DAR. She maintained a keen mind and sense of humor until her death at the age of 94 in 1985. (BFF.)

When his father became ill, Isaac Wyatt Byrd took over the family bottling business, and it became Byrd and Son. He was appointed to a vacancy on the Bay County Commission, where he served for 25 years. He was most proud to have played a role in bringing a four-year college to Bay County. Even with serious health problems, he kept his sense of humor and continued his political, civic, and philanthropic endeavors until his death in 1985. (BFF.)

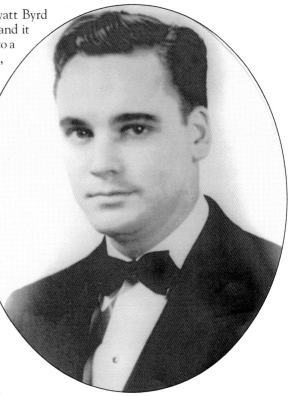

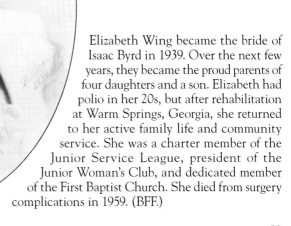

Elizabeth Wing became the bride of Isaac Byrd in 1939. Over the next few years, they became the proud parents of four daughters and a son. Elizabeth had polio in her 20s, but after rehabilitation at Warm Springs, Georgia, she returned to her active family life and community service. She was a charter member of the Junior Service League, president of the Junior Woman's Club, and dedicated member of the First Baptist Church. She died from surgery complications in 1959. (BFF.)

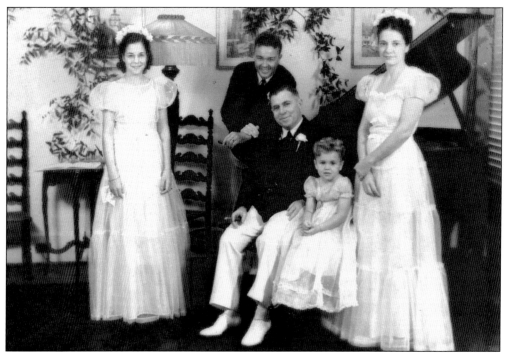

The wedding party of Elizabeth Wing and Isaac Byrd poses in living room of the Harry and Lottie Fannin home on West Beach Drive in 1938. From left to right are Lottie Wing, Marion Nelson, Harry Fannin, Gretchen Nelson, and Dorothy Wing Weis. The tasseled floor lamp in the background was a gift of Harry Fannin to his wife on their first anniversary. It is still in the family today. (NFC.)

The family and friends of John Sr. and his wife, Irene Christo, are gathered on the front lawn of the Christo home on Beach Drive in 1937. They are together to celebrate the baptism of twin sons, George and Jimmy, born to John and Irene in July 1936. Pictured from left to right are (seated) John Christo Sr., Marietta Mathews (Irene's sister), Gladys Christo, Agalinio A. Apostle, and Philip Mathews; (standing) A. I. Christo, Angelus Christo (John Sr.'s brother), Vickie Apostle, Ernest Apostle (Irene's brother), Mrs. Ernest Apostle, John Apostle (Irene's brother), Irene Christo, and John Christo Jr. (BCPL.)

L. D. Lewis and his wife, Leona, moved to Panama City from Marianna in 1944 to open their own grocery store on Harrison Avenue at Seventh Street. The Jitney Jungle Food Store was a franchised store chain out of Mississippi. Panama City welcomed the store at a time when the population was growing rapidly because of shipyard workers. Eventually, there were seven Jitney Jungle Food Stores in the bay area. In the early 1960s, L. D. left the franchise and renamed the grocery stores Sunshine Food Stores. Thus, he acquired his nickname "Sunshine" Lewis. (LFC.)

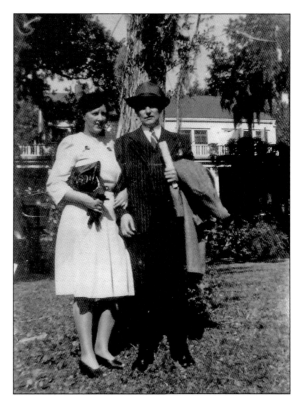

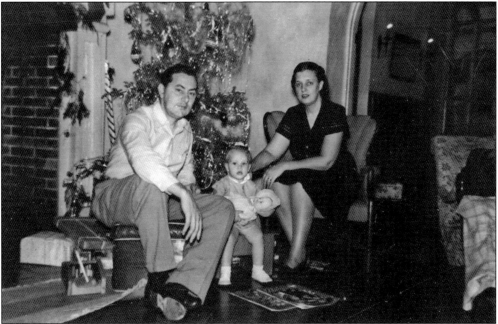

Christmas 1947 finds the Lewis family celebrating together with baby daughter Lana Jane in their Sudduth Avenue home. Not only did Leona Lewis take an active role in the family business, but young Lana did as well, eventually becoming its president. Another daughter, Donna Sue, and son, Luther D. Jr., completed the Lewis family. (LFC.)

John Christo Sr. is pictured with sons A. I. Christo and John Christo Jr. They are on the front steps of the home that John Sr. built for his family at the corner of Allen Avenue and Cherry Street. Six sons and one daughter were born to John Sr. and Irene. (BCPL.)

Philip Mathews told his friend John Christo that he knew of a young woman in Greece who wanted to come to America. He asked if John would be interested in marrying her. After a look at her picture, John agreed. Phillip's wife was making the same inquiry of Irene Apostle in Greece. She too agreed. John and Irene were married in Mobile, Alabama, in 1921. They raised a fine family, operated a very successful business and were married for almost 50 years. Pictured are John. Sr. and Irene in 1961. (BCPL.)

Two

HOMETOWN

According to the journal of Spanish American War veteran Capt. Harry M. Felix, "The first notable house in Panama City was built by Marion Jenks, corner Second Street and Luverne Avenue. Just above the city dock was what we called the 'swimmin hole.' An hour or two before sundown most of the citizens would congregate there for a dip in the bay. . . . Amongst these people we found some congenial friends and although still living on the boat we commenced to call it home and made it our Post Office."

Captain Felix arrived in Panama City in 1907 and opened his business on First Street at Tarpon Dock. He was both a sign painter and an artist. The Panama City area was his home until his death in 1954 at the age of 86. Both his paintings and his brief journal offer a glimpse of the city's history.

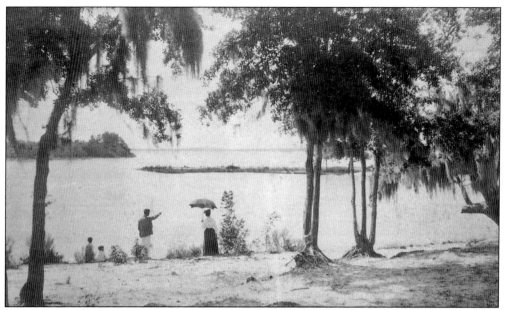

This picture is from a collection of photographs of West Florida commissioned by the Louisville and Nashville Railroad. It was intended to introduce the "Delightful summer and winter country for tourists and home seekers for a temperate and healthy climate" to potential settlers. It would appear that the people are enjoying the beautiful view of St. Andrews Bay. (LHC.)

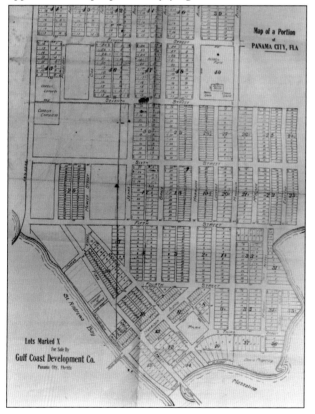

This map was prepared by the Gulf Coast Development Company as part of their sales plan. It indicates the location of streets in the business district as well as in residential areas. There is little development north of Thirteenth Street. Note several streets have changed names over the years. Lots still available for purchase are indicated by a checkmark. (BCPL.)

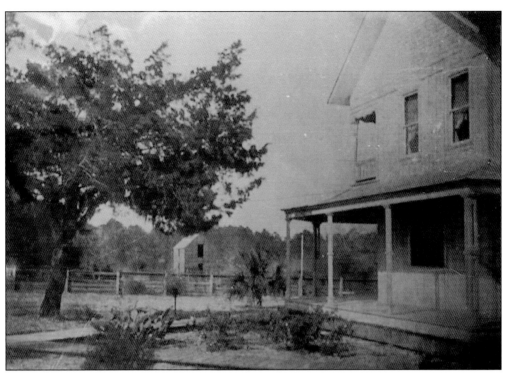

This frame home belonging to George M. West, with its generous porches, was located on a bluff overlooking St. Andrews Bay between Panama City (Harrison) and St. Andrew. When Panama City was incorporated, the house was not within the boundaries, and West was unable to vote in its first election. The house was built about 1906. West was able to enjoy his hobby—the study and observation of plant life—on the land surrounding the house. (BCPL.)

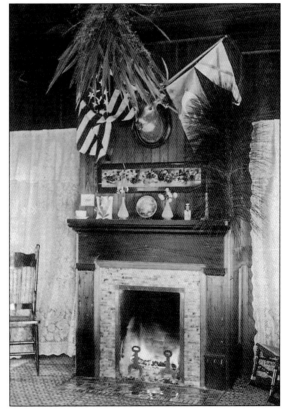

This view of the east side of the front room shows the fireplace and mantel in the G. M. West home. Here it is decorated for the Christmas holiday with native plants. Note the palmetto fronds and Spanish moss used with pine branches, all quite plentiful in the area. Several generations of the West family enjoyed warmth and fellowship in front of this fireplace. The caption attached to this picture read "At last the great logs, crumbling low, sent out a dull and duller glow." (BCPL.)

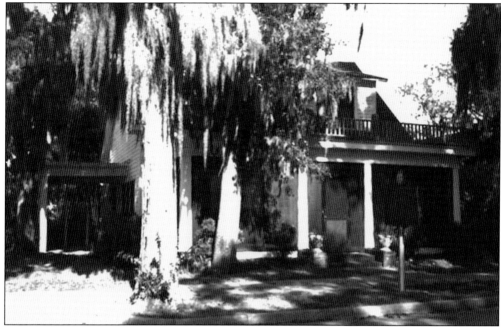

The McKenzie home was built in 1909 by Belle Booth, the widow of Dr. Booth and the postmistress of Panama City. In 1912, she married Robert L. McKenzie, businessman, banker, and mayor. After Belle's death, McKenzie married local schoolteacher Blandford Dixon. Since his office was in the front room, the home was the scene of many business and municipal meetings. During World War II, servicemen were always welcome to enjoy the piano and have refreshments. The house was placed on the National Register of Historic Places in 1986. (BCPL.)

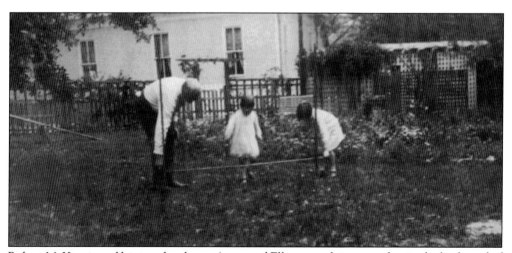

Robert McKenzie and his two daughters, Anne and Ellen, spend time together in the back yard of their home. Daughter Anne later recalled that her father had already made his fame and fortune when the girls were born, so he had plenty of time to spend with them. The white building with long windows in the background was the first schoolhouse in Panama City. It was adjacent to the McKenzie home. (BCPL.)

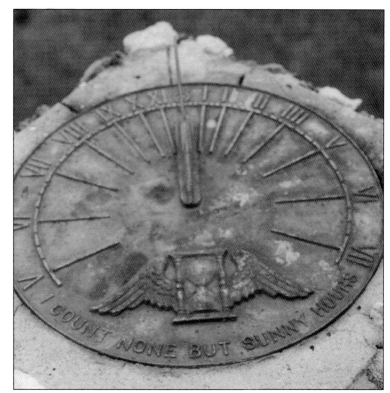

This charming old sundial on a stone mosaic pedestal is located in the McKenzie garden. The inscription reads, "I count none but sunny hours." Beneath the shady canopy of oaks and magnolias draped with Spanish moss, the sundial may not have been in the sun much of the day, but it probably measured sunny times for the McKenzie girls and their playmates. The McKenzie house was purchased by Panama City in 1994 and renovated with help from the Junior Service League. (BCPL.)

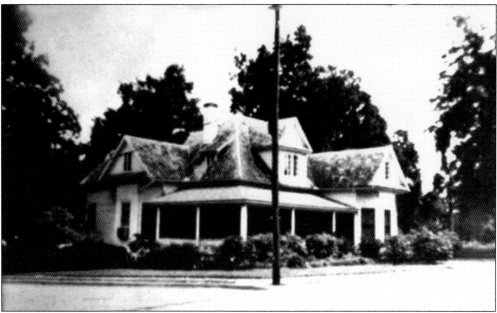

In 1907, M. B. Jenks built this home at 36 Oak Avenue overlooking the city park as a wedding present to his bride. Unfortunately, Jenks did not live for very many years after their marriage, and the widowed Mrs. Jenks married W. F. Look. The house was later occupied by A. J. Gay and then by the J. D. Blackwell family. In its 100th year, the house is as attractive as ever. It has been renovated and is currently the office of a local attorney. (BCPL.)

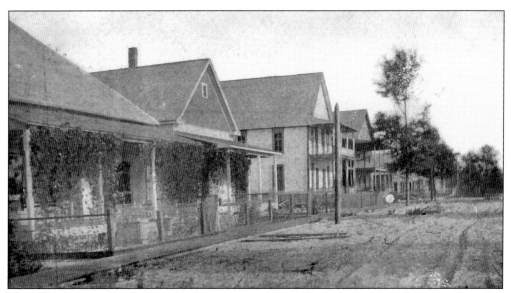

These lovely homes lined Magnolia Avenue around 1914. The house on the left, at 427 Magnolia, was the home of Presbyterian minister W. C. Wallace. The second house belonged to the Harris family. The third house was once occupied by Judge J. R. Wells and his family. The house on the right in the far distance belonged to the Whittles. Later it was the location of the Southern Bell Telephone Company. (LHC.)

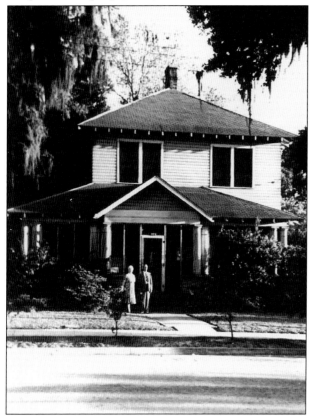

Joshua Mercer Sapp built this home at 224 East Third Street in 1916. Tradition says that once the courthouse was completed, he purchased the used scaffolding and framed his house with it. The house was the first in town to have two bathrooms and hot water. Later an elevator was installed. Since Sapp was an attorney, a judge, and served two terms in the state legislature, the porch became a gathering place for attorneys and politicians. The house is now on the National Register of Historic Places. (BCPL.)

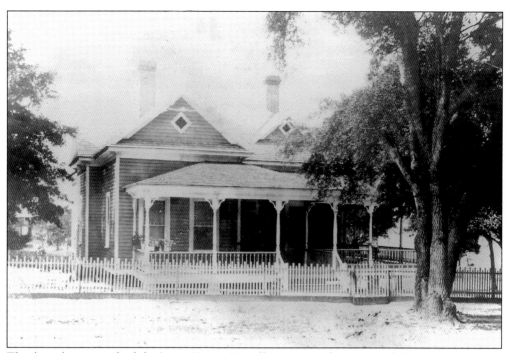

This large home was built by Lewis Henry Howell in 1909 at the corner of what was then Olive Street and Second Street. Olive Street later became Beach Drive. The Howells raised their three children—Floie, Nellie, and Brown—in this home. (HFC.)

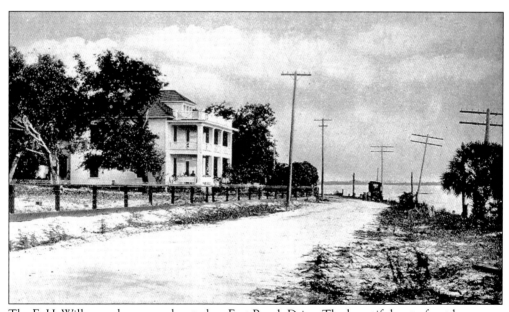

The E. H. Wilkerson home was located on East Beach Drive. The beautiful waterfront home was the site of many of Panama City's early social functions. Nellie Wilkerson is referred to as both a businesswoman and civic leader in *Panama City Pilot* articles. (LHC.)

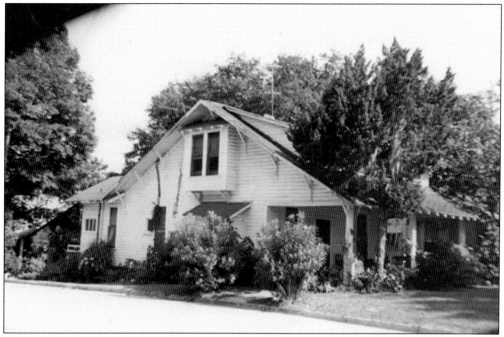

This late photograph shows a home on the corner of McKenzie Avenue and Third Court, south of the courthouse. It is one of three that were built there in 1912 by contractor M. B. Hawkins for R. R. Powers. Powers served in World War I as an army officer. He organized the Panama City National Guard in 1922. After the war, he went to work for the Coca-Cola Company in Paris, France, where he was later killed in an automobile accident. (BCPL.)

These ladies may be shopping for land on the outskirts of town. The scene is near the corner of Ninth Street and Grace Avenue sometime during 1912. The woman on the right is unidentified, but the one on the left is Elsie Jordan, who later married W. A. Davis. (LHC.)

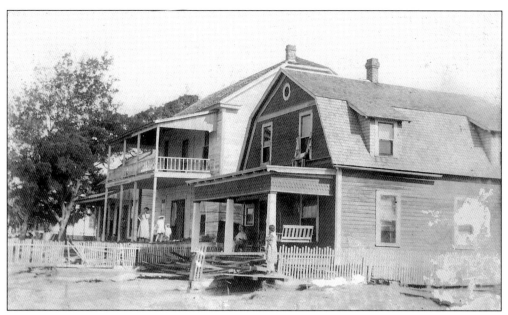

These early homes were located on First Street around 1914. The home on the right belonged to the Elwood family, and the next was the home of Wilson Tasker and his family. Tasker was an early photographer in Panama City and also owned and operated pleasure boats. His wife and two of her children can be seen on the front porch. Look closely to see the damaged fence, the pile of boards in the yard, and other indications of windstorm damage. (LHC.)

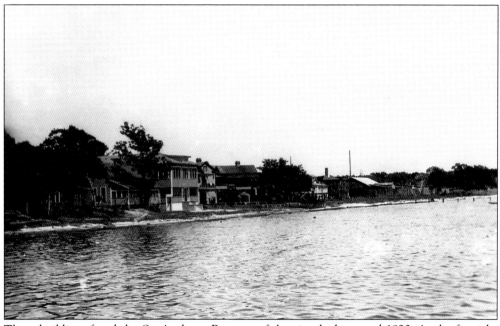

These buildings faced the St. Andrews Bay east of the city dock around 1920. At the far right is the Bay Manufacturing Company, owned by G. B. Jones. In the center of the picture is the Panama Hotel. (LHC.)

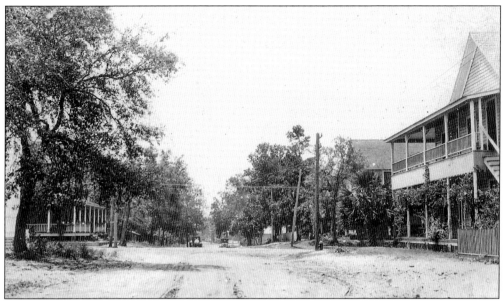

Around 1920, this would have been the view from Grace Avenue at Fifth Street looking south. The house on the left is the Baptist parsonage, and on the right is the Dixon house. Travel along even the most populated roads was not always easy, as there were no paved roads in the county until 1924. (LHC.)

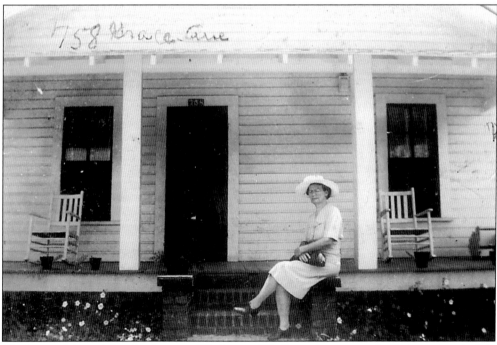

The home of Ammie Lee Jr., the son of Dr. Lee, at 758 Grace Avenue was built in sections by Mr. Hobbs and Mr. Spiva in West Bay. It was then transported by barge and erected at its permanent location. The woman seated on the porch is Mary Cooper Weston, the mother of Ammie's wife, Sue. (SLC.)

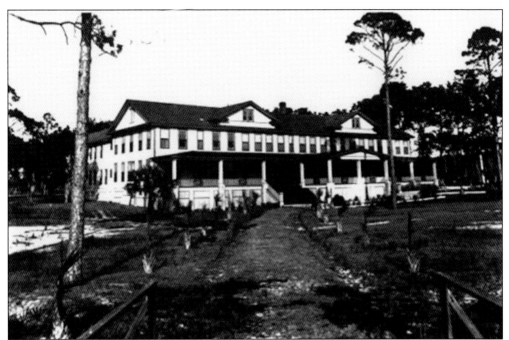

The Pines was located near the railroad depot at Sixth Street and Beach Drive. It was built by the Atlanta and St. Andrews Bay Railroad in 1910 as a clubhouse, but it was remodeled into a hotel. By 1932, the Pines Hotel was owned by Minor C. Keith Florida Properties and the St. Andrews Bay Lumber Company. On a November morning that year, the roof caught fire. The west wing was quickly engulfed in flames, and soon the entire building was consumed. (BCPL.)

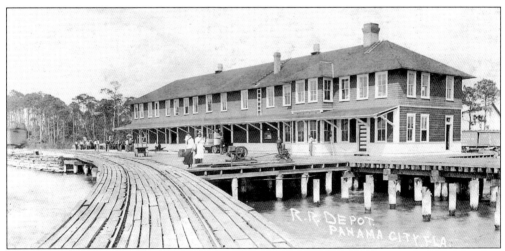

The Atlanta and St. Andrews Bay Railroad built this railway depot around 1908. The first passengers—some 250—arrived from Dothan, Alabama, on June 29, 1908. This building burned on January 7, 1924. Railroad owner Walter Sherman announced that the company had plans to build a new depot on the east side of the tracks even before the fire. Since plans were already drawn, the new depot, featuring cement floors, two massive vaults, and loading docks, was completed in 60 days. (LHC.)

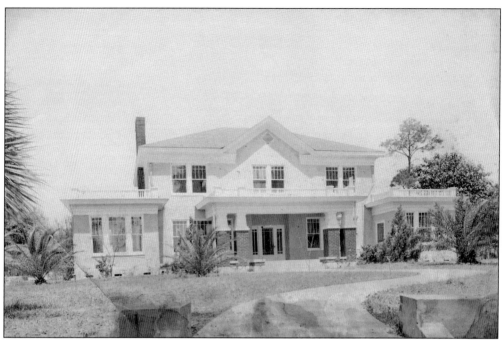

A. A. Payne, president of the First National Bank of Panama City, built this large masonry home on West Beach Drive in 1925 after losing two earlier homes on the same site to fire. It was purchased by the Christo family in 1934 and continues to be a landmark home on the bay front. (BCPL.)

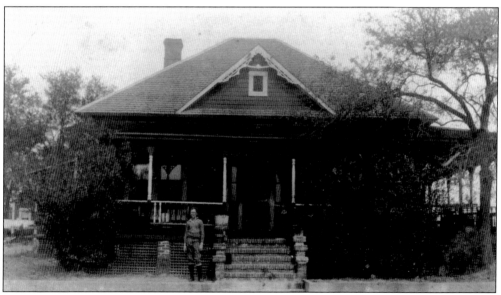

Over the years, the Nelson family made many moves. They first lived in Southport, but then moved to a Magnolia Avenue address in Panama City. When Frank Sr. bought a car agency in Mariana, the family spent a year there. For a time, they lived on McKenzie Avenue near the courthouse. This house on Fifth Street was their last move, and their last two children were born there. Standing in front of the house is young Bubber Nelson dressed in his Eagle Scout uniform. (NFC.)

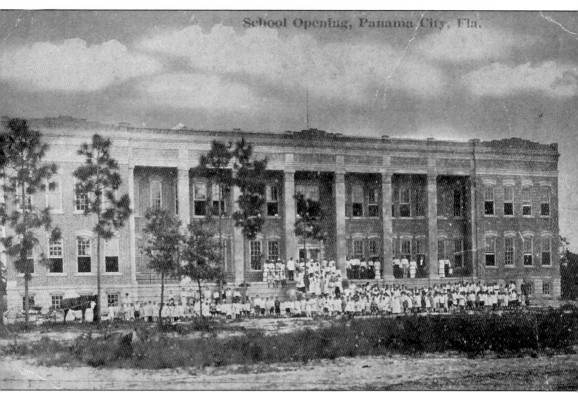

Panama Grammar School opened its doors in September 1914. Pictured out front on that day are Panama City's school-age sons and daughters. S. J. Welch was the architect, and Dobson and Olive were the building contractors. The school board members were W. B. Merrett, A. H. Miller, and R. D. Murray. E. L. Brigman was the superintendent of public instruction. With the fall term of 1917, the 11th and 12th grades were moved there from Lynn Haven. The last graduation held there was on June 4, 1926, when 33 students received their high school diplomas. The graduation address was given by the Reverend Robert Jones. The class of 1927 graduated from the new Bay County High School. At that time, Panama Grammar truly became a grammar school. In the 1960s, the building was purchased by the First Presbyterian Church to house its Sunday school and administrative offices. (WAC.)

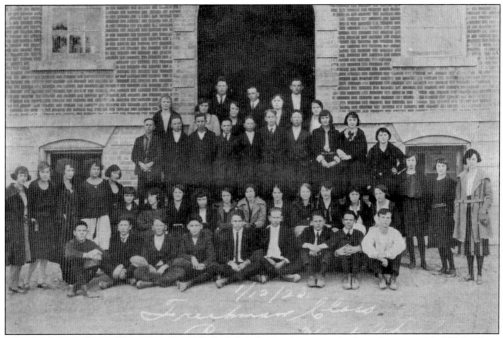

The freshman class of Panama City High School was photographed on January 12, 1923. Class officers were Henry Starling, president; Merritt Brown, vice president; Zuleima Mathis, treasurer; and Evelyn Marshall, secretary. For their class colors, the students selected blue and white. Their class motto was "Green but growing." (GFC.)

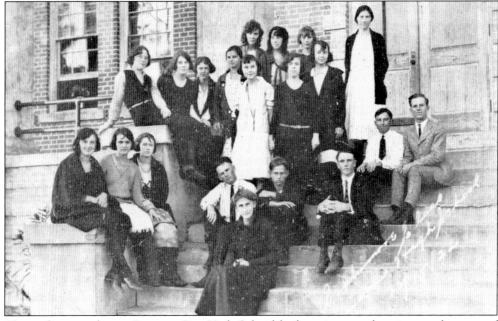

The sophomore class at Panama City High School looks quite casual posing on the steps of the school on December 15, 1922. However, the faces of these well-dressed young men and women seem quite serious. Their class motto was "The elevator to success is not running; take the stairs." (GFC.)

"THE PELICAN"

PUBLISHED BY THE STUDENTS OF THE PANAMA CITY
HIGH SCHOOL, PANAMA CITY, FLA.
1922-23.

STAFF

Miss Wilkie Bowen	Faculty Advisor
Ben Ellis	Editor-in-chief
Theodore Williams	Assistant Editor-in-chief
Angus Laird	Business Manager
Geraldine Sharpe	Assistant Business Manager
Irvin Wells	Alumni Editor
Mazie Sims	Literary Editor
Randall Newberry	Jokes
Roy Laird	Jokes
Donald Hills	Senior Representative
Margaret Harrison	Junior Representative
Catharine Wells	Sophomore Representative
Evelyn Marshall	Freshman Representative
E. W. Masker	Photographer

LOCAL BOARD OF TRUSTEES

J. R. Wells, Chairman
W. H. Marshall
W. F. Look

COUNTY SCHOOL BOARD

C. C. Mathis, Superintendent and Secretary
R. D. Murray
R. L. McKenzie
A. M. Douglas

This is the title page from the Panama City High School yearbook for 1922–1923. The 23 graduating seniors dedicated their annual to their "beloved teachers, to the alumni, to their parents and to their friends." Its name, the *Pelican*, was chosen from suggestions submitted to a selection committee. Ben Ellis, president of the graduating class, is credited with the suggestion. He was also voted best athlete by his classmates that year. (GFC.)

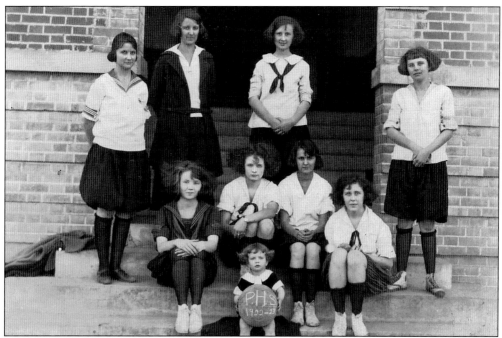

These young ladies are the girls' basketball team of Panama City High School for the 1922–1923 season. According to their yearbook, they are (in no particular order) coach Leah Ramie; Florine Harrison, captain and forward; Iva Mae McBride, forward; Lucille Purcell and Nadine Ryals, centers; and Kitty Middleton, Jack Mayers, and Margaret Harrison, guards. The baby is not identified. (GFC.)

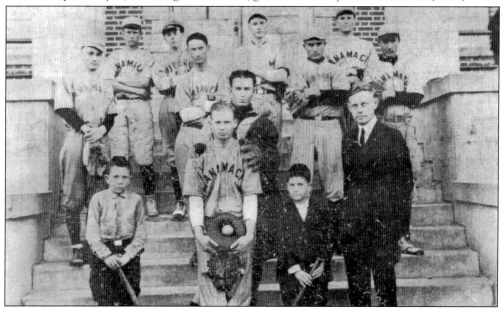

Panama City High School fielded a baseball team in 1922. The principal, G. Ballard Simmons, was their coach. They are only identified by position, but members were Ben Ellis, captain and catcher; Henry Starling, pitcher; Martine Dean, first base; Seaborne Sharpless, second base; Moland Jordan, shortstop; Burma Pilcher, third base; Hurdis Turner, left field; Charlie Powell, centerfield; Theodore Williams, right field; and William Middleton, substitute. (GFC.)

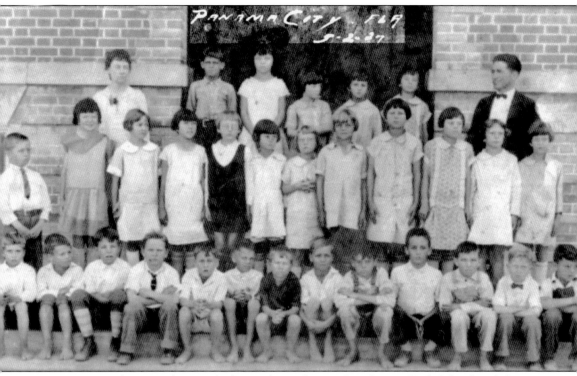

By May 2, 1927, the upperclassmen had moved into the new Bay County High School, and these youngsters were enjoying their days at Panama Grammar School. Shoes do not seem to be a part of the dress code. From left to right are (first row) unidentified, Jack Gainer, unidentified, Henry McQuagge, unidentified, Alf Coleman, Harold McKenzie, Sam Johnson, Ralph Prowse, Mitchell Glover, John ?, and Ise Schneider; (second row) unidentified, Doris Hartzog, Carolyn Elmore, Edna Baldwin, May Lee Davis, Maybelle Varlin, Kate Nelson, Mazie Hartzog, Occie Hartzog, Lois Carlos, and Virginia Sorentino; (third row) ? Roosevelt, Frankie Thomas, Winifred ?, Martha Vickery, and two unidentified. (BCPL.)

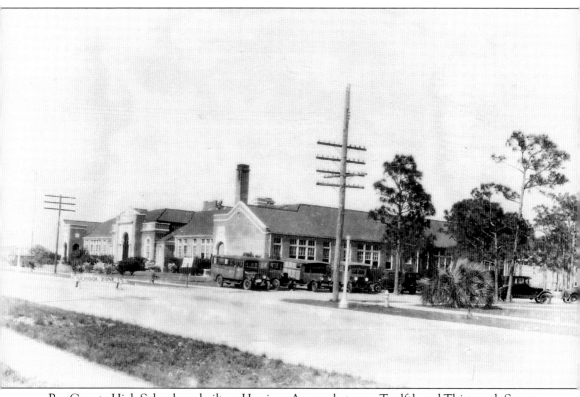

Bay County High School was built on Harrison Avenue between Twelfth and Thirteenth Streets. It was completed with the laying of a dedicatory cornerstone on September 13, 1926. Presiding over the occasion, Judge Amos Lewis of Marianna said, "We dedicate this building to the cause of religious freedom, humanity, Christianity and education." Notice the school busses parked beside the building. (BCPL.)

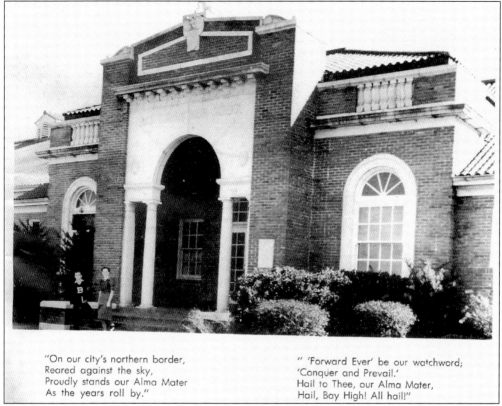

"On our city's northern border,
Reared against the sky,
Proudly stands our Alma Mater
As the years roll by."

" 'Forward Ever' be our watchword;
'Conquer and Prevail.'
Hail to Thee, our Alma Mater,
Hail, Bay High! All hail!"

This is the original facade of Bay County High School before it was remodeled in 1970s. The image is held near and dear to the hearts of hundreds of Bay High alumni. The first line of the alma mater reminds everyone that the school was at the city's northernmost boundaries. (AC.)

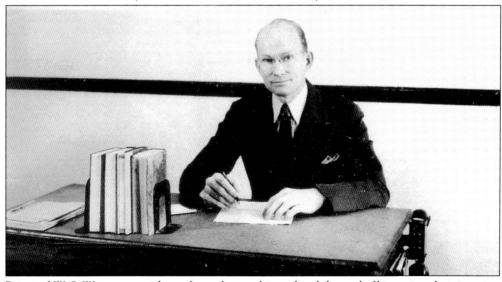

Principal W. S. Weaver set guidance for students as his goal and the goal of his entire administration at Bay County High. According to his message in the 1940 yearbook published by the senior class, it was important to help each pupil improve his personal and social life. (AC.)

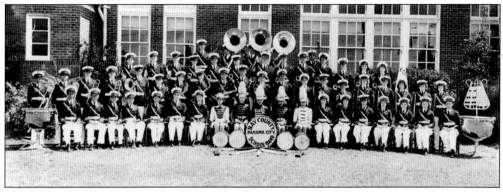

The Bay County High School band posed for this picture in 1941. Since they were the only high school marching band, they were called on to provide music for all parades and celebrations. There was never any problem filling the ranks in such a popular group. (BCPL)

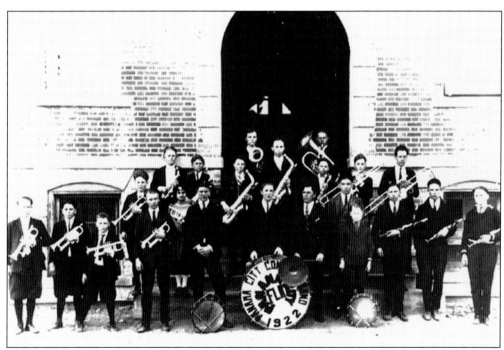

Bay County High's band is shown with its director, Ralph W. Sorentino. The picture was taken when the band was in its infancy. From left to right are (first row) Ralph Hill, Alex Miller, Marion G. Nelson, Steadman Hobbs, Kid Dean, John Stokes, Sorentino, Preston Jones, Bill Stevenson, Stanford Bacon, and Henry Gray; (second row) Rae Steel, Susie Goodgame, and Donald Davidson; (third row) Marvin Porter, Frank Nelson Jr., Huston Jones, Bascom Hobbs, Earle Boone, and Harrison Wilson; (fourth row) Leon Scott, Mae Anderson, and Henry Goodgame. (NFC.)

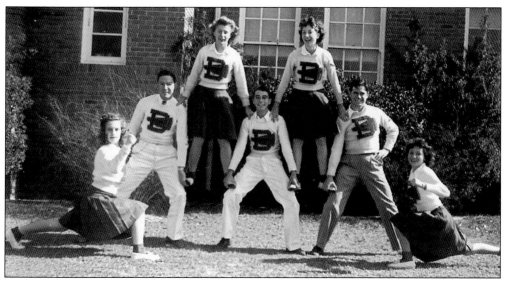

Several names well-known around Panama City appear on the roster of the 1942 Bay County High School cheerleading squad. Pictured from left to right are (first row) Ann Bannerman Gray, Unknown, Jimmy Baxley, R. A. Smith, and Mildred Penton Richberg; (second row) Ann Coleman and Elizabeth Hutchison Locke. (GFC.)

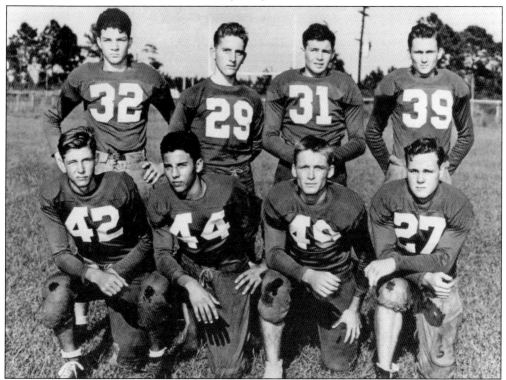

These young men are the Bay County High School football lettermen. The photograph was taken prior to their season-opening game in September 1944. Shown from left to right are (first row) W. C. Cooper, Frank Sullivan, Harold Conrad, and Jim Pledger; (second row) George Stone, Silas Hodges, Charles Eddins, and John Warren. (RCC.)

Mr. and Mrs. W. O. Byrd are standing in front of their home on South Palo Alto Avenue. They moved into this house in April 1959. Mrs. Byrd lived there until her death in 1985. For 17 years, the house was used as a residence for many different Southern Baptist missionaries while they were home on furlough from sites around the world. The house is now occupied by one of Olivia Byrd's granddaughters. (BFC.)

The Grace Avenue home of Ammie Lee Jr. and his wife, Sue, is seen as it appears after additions and alterations over the years. The Lee family continues to occupy the home, which is nearing its 100th birthday. (SLC.)

Nestled beneath oaks and surrounded by azaleas, the home of David and Anne Gray overlooks Lake Caroline not far from downtown Panama City. Here they raised four daughters. (GFC.)

The lovely house on Beach Drive was the home of Isaac and Elizabeth Byrd and their three daughters, Beth, Pam, and Olivia. The family lived here until 1953, when they moved to a new house at 824 West Beach Drive. Elizabeth's sister, Marion, and Marion's husband, Bobby Nelson, who lived next door, bought the house and connected it to theirs with an enclosed breezeway. (BFC.)

This private kindergarten, owned and operated by Madelyn Gore, was located on Magnolia Avenue in downtown Panama City. Many prominent families enrolled their children at Gore's kindergarten. She is shown in the center of this photograph with her class in May 1956. Pictured from left to right are (first row) Avis Shores King, Beverly Nixon Dusseault, Cissy Daffin Senechal, Barbara Mitchell Leonard, Mae Gray Morris, Kathy Ullman Barr, Ann Kruse Percival, Gwyn Hughes, Margaret Lokey, Shawn Sweet, Linda Eley, and Candy Lang; (second row) Bobby Bruce, David Hindsman, Jimmy Cason, Craig Fontaine, Craig Strickland, Keith Strickland, Steve Humphreys, John Benton, Rod Morris, Hunter Jennette, and unidentified. (GFC.)

Three

SOME SIGHTS AROUND TOWN

Over the years, there have been some unusual and notable sights around town. Captain Felix recorded the story of a swim and a notable sight in his journal. One evening, while he and his fellow citizens of Panama City were taking a dip in the bay, "a very large disturbance was noticeable by the side of us" he said. "Nothing was said about it but all looked around at each other and we suddenly concluded to adjourn. Poor me, I had to swim out to the boat which was anchored about 100 yds away. . . . I did not enjoy that swim a bit." While at work the next day he heard the sound of rifle fire in the direction of the dock. Rushing to his boat at the dock, he found, "Mrs. Felix had crippled a 10½ foot alligator and finally killed it. We towed it to the beach and skinned it. We think the boil in the water the day before was caused by same."

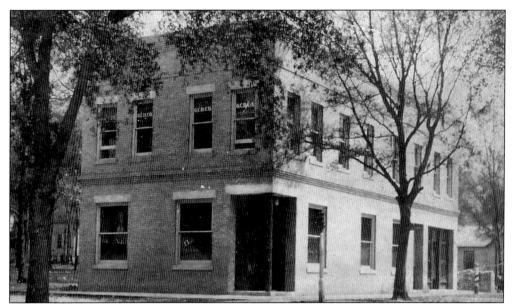

The Bank of Panama City opened its doors on May 27, 1908. George Mortimer West was the president. This was the first brick building in Panama City. The Gulf Coast Land Development Company occupied offices on the second floor. The bank went into receivership in 1915. In the next few years, this building also housed the first site of the Western Union telegraph office and the first telephone exchange. Dr. Lingo, Dr. Fellows, and Dr. Frazier each later had offices on the second floor. (LHC.)

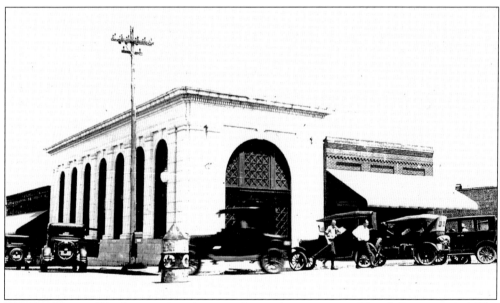

The First National Bank opened its doors on the northwest corner of Beach Drive in 1916. The old charter from the Bank of Panama City was purchased by A. A. Payne and reopened across the street as the First National Bank. This bank failed and went into receivership in March 1931. W. C. Sherman was both a director and a principal stockholder. M. E. Murray was the court-appointed receiver of the bank. (LHC.)

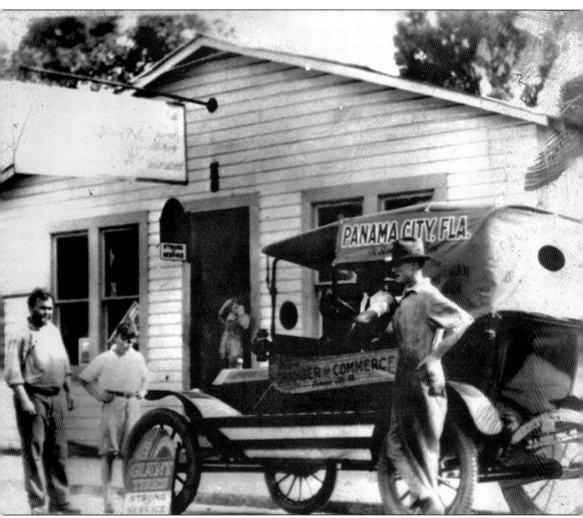

The Bay County Chamber of Commerce was organized in 1913 and has been an important part of the business community from that time until the present. Its mission is to develop, enhance, and maintain a viable business climate and to provide leadership in the development of economic growth and quality of life. This welcome wagon came out to greet new businesses and residents in the early 1920s. On this day, the wagon and its ambassador appear to be making a stop at a service station or tire store. (BCCC.)

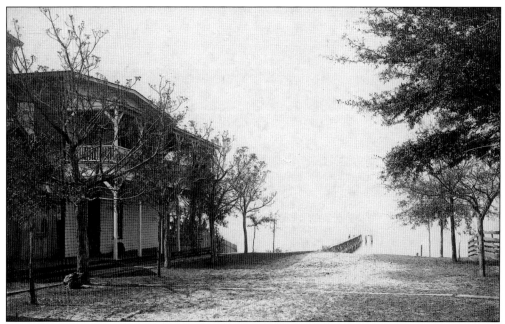

The Gulf View Inn was built by C. J. Demorest in 1889. Captain Felix mentioned seeing two structures across the water near Red Fish Point in 1907. He thought they were old residences but later learned that one was the Gulf Coast Development Company's office and the other a three-storied, wood-frame hotel with 10 rooms. It was operated by the Crawford family, who came from Dothan, Alabama. The Gulf View burned in 1916. (LHC.)

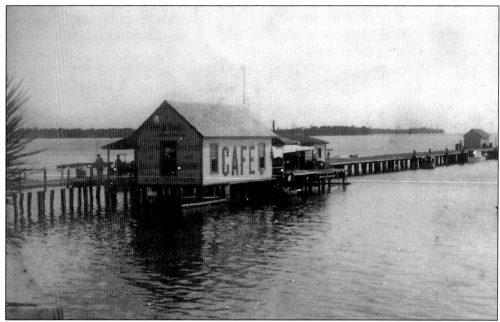

This is a view of the first city pier located at the foot of Harrison Avenue. After the railroad came into Panama City, a rail track was extended onto the pier for ease in unloading ships, including the *Tarpon*. Early Panama City depended heavily on ships and boats to move goods as well as people around the surrounding bays. (LHC.)

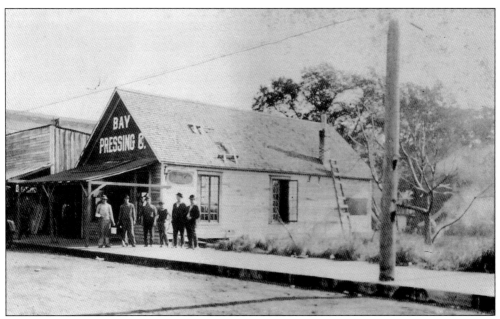

This small wooden structure was located near the foot of Harrison Avenue on the east side. As the community grew, most of these early business buildings were replaced with brick and masonry structures. Fires claimed many of them in the early years. (BCPL.)

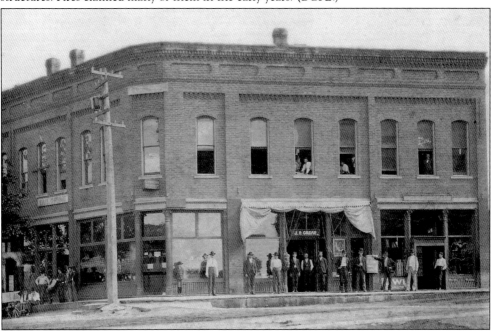

There are a number of conflicting identifications of this building. Some say it is the Gay Building, others the Wilkerson Building, and others the Gilbert Building. Either it is not standing today or has been remodeled beyond recognition. Regardless, this is a most interesting photograph reflecting life at the time. Upstairs are a doctor's office and a dentist's office. On the ground floor, there is a tailor's shop, a cafe, a bank, and possibly a dry goods store. On the left, a wagon is making a delivery. One can only guess what has drawn the attention of the men on the sidewalk. (LHC.)

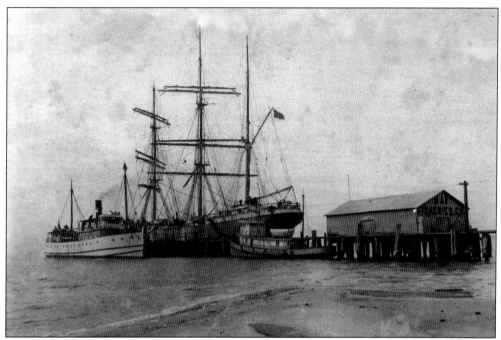

Bay Fisheries and Panama Ice Plant were located at the foot of Frankford Avenue with a rail line extending out onto its pier. Although an apartment complex occupies the site today, the pilings from the old wharf and pier are still visible in the waters of the bay. (BCPL.)

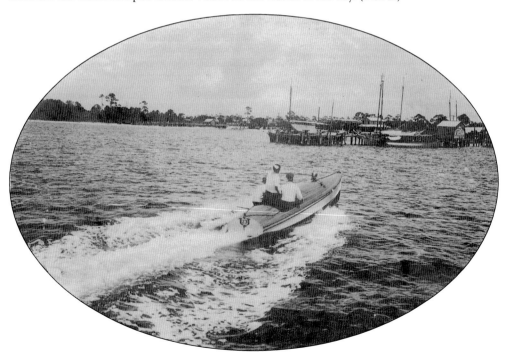

A little wooden skiff speeding across St. Andrews Bay may look like entertainment, but it was the easiest way to travel in the early days of Panama City. (BCCC.)

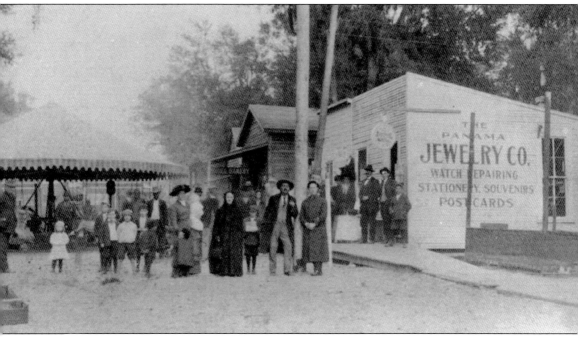

In 1912, the city fair day seems to be quite an event. This scene is on Harrison Avenue near the location of the Regions Bank today. Note that the streets are not paved. Advertisements on the jewelry store building indicate they repair watches and sell stationery, souvenirs, and postcards. There is a bakery next door. A round tent has been set up in the middle of the road, and some activity is drawing young and old. The woman in the large hat holding a baby is Lucy Carden, and the baby is named Vashtie; the child in front is Cora Carden. The woman in the dark cloak is Vinnie Carden. Leaning on the post is Thomas Carden. (LHC.)

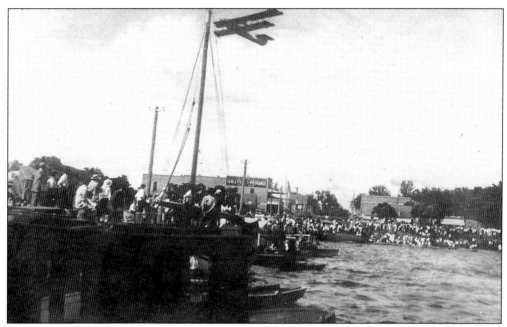

The city pier is crowded with people celebrating the Fourth of July. Their attention is drawn upward as one of the first planes ever to fly over the city makes a pass over the pier. The year is said to be 1917. (LHC.)

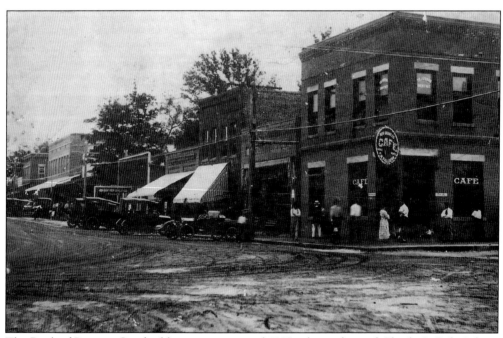

The Bank of Panama City building is seen around 1925, when it housed Charley's Café. It later housed the offices of Sudduth's Bunkers Cove Development Company. The eastern section of Beach Drive was still known as First Street in those days. (LHC.)

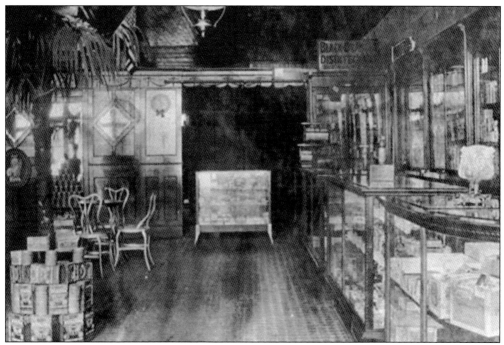
Here is a view of the interior of Brewer's Drug Store, complete with soda fountain. The bent-cane chairs and table are typical of the times. The store sold medicines, remedies, and household and beauty products. (BCPL.)

The variety of items available at Surplus Sales was unlimited. Display space and storage were scarce, so many items were hung from the ceiling. This store was located in the Van Kleeck building, constructed in 1933 at 131–135 Harrison Avenue. (BCPL.)

It is Circus Day, 1916, in Panama City. This photograph of a wagon in the circus parade was taken at the corner of Harrison Avenue and Fifth Street. The two-story house on the corner was later moved east of the city park and operated by the Henderson family as a boardinghouse. This corner was later occupied by the Marie Hotel, which was built in 1931 by A. R. Rogers. (LHC.)

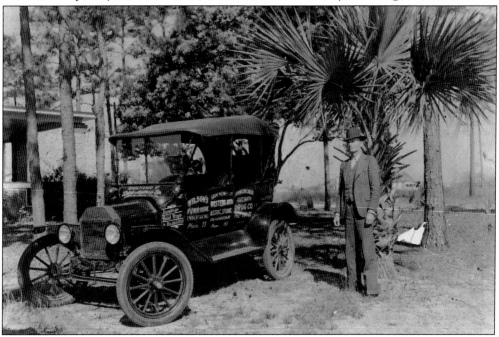

This car transports its owner, Josh Pollock, and at the same time advertises for a number of businesses in the city. There is an advertisement for the Dixie Mattress company, the Wilson Furniture, Hardware, and Undertaking business, and the Western Auto affiliate—all in the lettering on the car. (BCPL.)

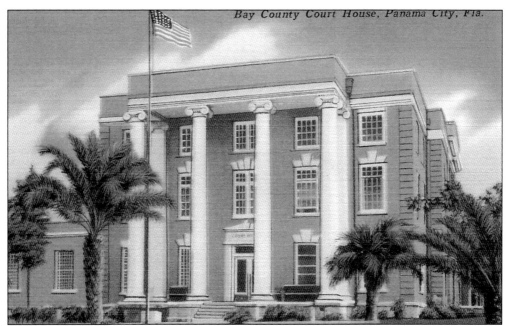

The Bay County Court House was built in 1913. The first term of court was held there in November 1915. Panama City's first permanent jail was located in a basement room of the building. Through the years, fire has damaged the building on several occasions. In December 1920, fire damaged the structure so extensively that most of the interior had to be rebuilt. (LHC.)

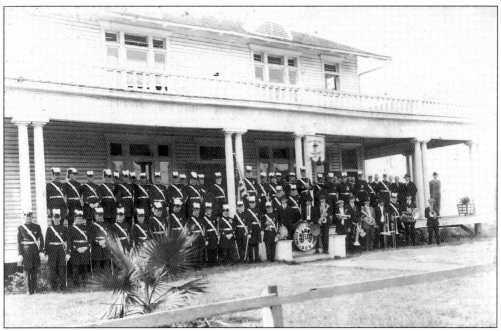

This is the Panama City Community Band dressed in their splendid uniforms and posing in front of the woman's club building on West Beach Drive. The year is 1922. Photographs indicate that for more than 100 years, musical entertainment has been an important part of Panama City's life. (BCPL.)

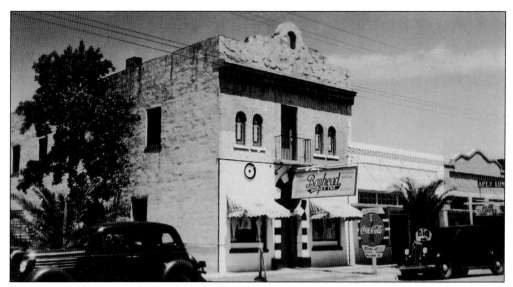

The Bay Head Dairy sold it products in this little building on Harrison Avenue. Ice cream was made here, and a sundae could be purchased for a nickel. The building had extra-thick walls, so it was well insulated against the summer heat. Today the building is known as the John Christo Sr. building, named for a previous owner. The building was recently designated one of Panama City's historic sites. (LHC.)

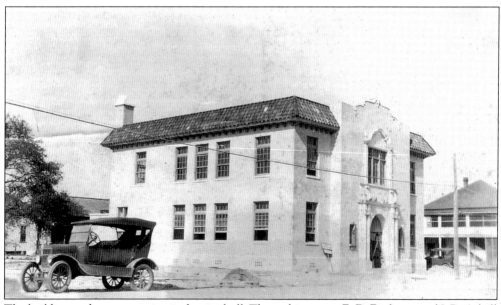

The building under construction is the city hall. The architect was E. D. Fitchner, and J. R. Asbell was the builder. The board of trustees for the project was E. H. Wilkerson, G. M. B. Harries, and F. M. Nelson Sr. (LHC.)

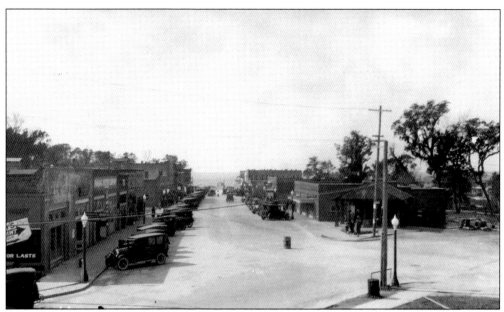

Here is a view of the same area from the opposite direction, looking south to the foot of Harrison Avenue from Fourth Street. The photograph was most likely taken from the scaffolding of the city hall. Harrison Avenue ends at the city pier. (LHC.)

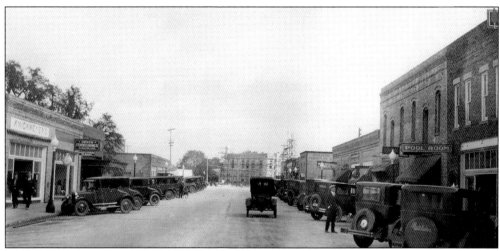

Take a look north from the 200 block of Harrison Avenue to the 400 block in 1925. The building under construction in the distance is the city hall. The building is designed to accommodate city officials and house the city jail. The two buildings on the immediate right were removed in the late 1980s to create the Gateway to McKenzie Park. In the late 1950s, a new city hall was built on the marina at the south end of Harrison Avenue, and city business is conducted there. The old city hall building now serves as the visual arts center. (LHC.)

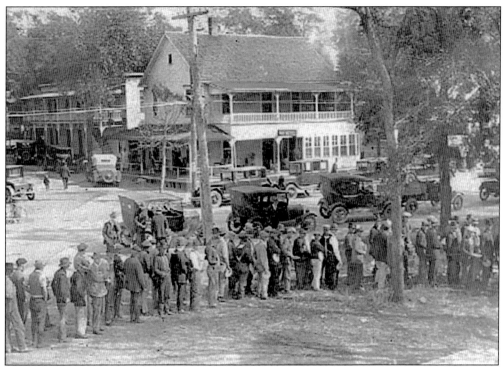

These men are standing in line to volunteer to work on the Bob Jones Tabernacle where once the Gulf View Inn stood. The Reverend Bob Jones was a popular evangelist who preached from this shelter. Jones was so well received and liked the area that he announced he would build a Christian college on property north of the city. Bob Jones College opened in 1927. (BCPL.)

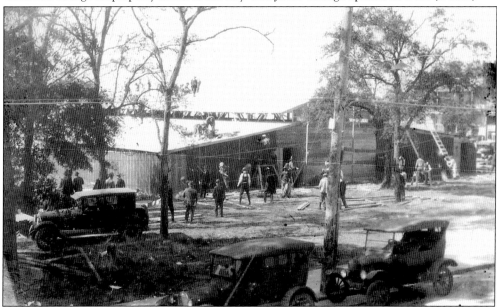

More of the tabernacle can be seen in this view from the rear side facing northwest. The building was constructed quickly and covered with tar paper. When it caught fire less than two years later, the blaze was visible all around St. Andrews Bay. (BCPL.)

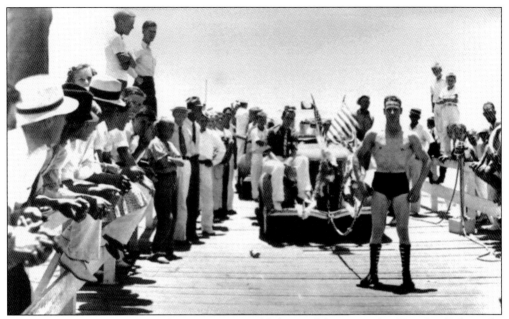

Again crowds are gathered on the city pier, most likely to celebrate another Fourth of July in the 1920s. The entertainment is a performance by Paul Conrad, a local strong man. He held the title of the Strongest Man in the South. Here he is harnessed to a number of cars and is about to pull them with his teeth along the pier. (RCC.)

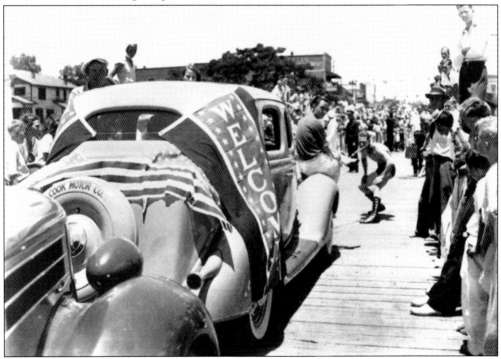

From behind the cars, Conrad can be seen pulling them. The man seated on the right front fender of the lead car is future mayor Carl Gray. Notice that the cars have been provided by Cook Motor Company, the local Ford dealership. (RCC.)

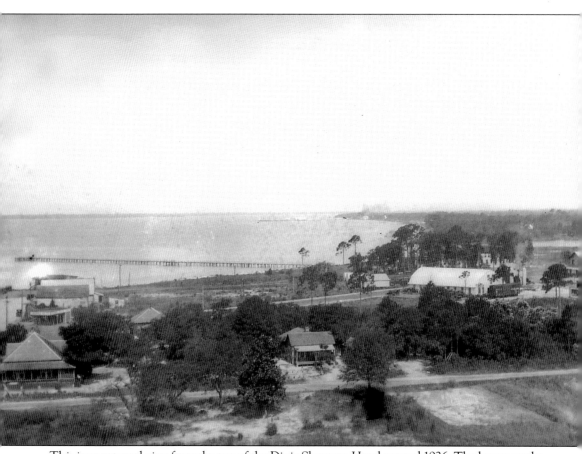

This is a westward view from the top of the Dixie Sherman Hotel around 1926. The house on the left is the home of Mayor Frank Nelson Sr. at the corner of Fifth Street and Oak Avenue. The house on the right is the home of Mrs. Tom Pumphrey, also on Oak Avenue. In the distance, almost hidden in the stand of pine trees, is the Pines Hotel. The hotel's pier can be seen stretching out from shore. On the far right is the Bay Line Depot, and at the far left is the Coca-Cola Company. The little point of land in the background is the location of the St. Andrews Ice Plant and Bay Fisheries. (BCPL.)

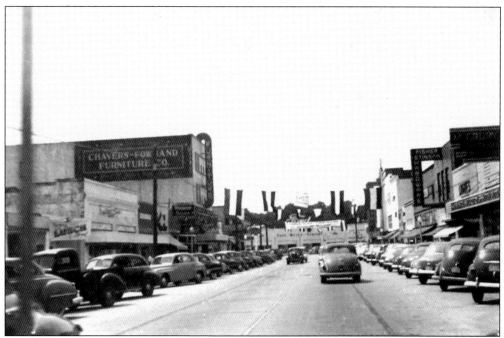

If the number of cars is any indication, Panama City was a busy place on this day in the late 1930s. Looking south on Harrison Avenue, notice the Chavers-Fowhand Furniture Store on the left. Across the street is the sign locating Fisher Stinson Hardware. The light-colored building at the center of the photograph is Cook Motor Company. (RCC.)

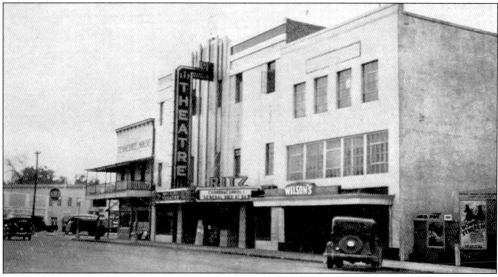

This picture was taken around 1936, just after the completion the Ritz Theater. To the right of the theater is located Wilson's Furniture, Hardware, and Undertaking. John Wilson built the building at 413 Harrison Avenue in 1926. It was the first three-story building in town. The Tennessee House is on the left side of the theater. When the theater opened on November 27, 1936, *Stage Struck* was the first movie shown. The manager of the theater was Henry Kimmel. The Ritz later became the Martin Theater. After being closed for a number of years, the Martin was renovated and reopened as a performing arts center in 1990. (BCPL.)

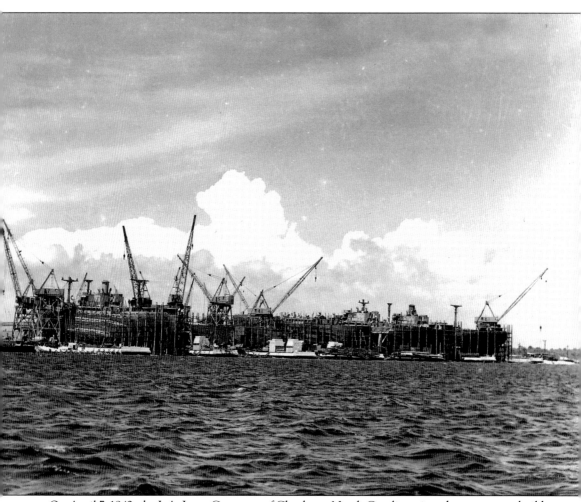

On April 7, 1942, the J. A. Jones Company of Charlotte, North Carolina, signed a contract to build a shipyard at Panama City, Florida, and produce Liberty ships for the military. A site of 112 acres at Dyers Point with almost 5,000 feet on St. Andrews Bay was selected. In a matter of days, work crews laid seven miles of railroad track to transport raw materials from the business district to the shipyard. Once site preparation was completed, the company proved its ability—the shipyard was completed in a record 79 days. The facility was named for Gen. Jonathan Wainwright, a prisoner of war, and the dedication service took place on May 22, 1942. Raymond A. Jones, company vice president and son of the owner, was on location to supervise the construction of the yards and the beginning of the actual shipbuilding. The general manager of the facility was H. V. Appen. Four hundred were on the job at Wainwright by July 1942, and by June 1943, employment numbers peaked somewhere between 15,000 and 18,000. (BCCC.)

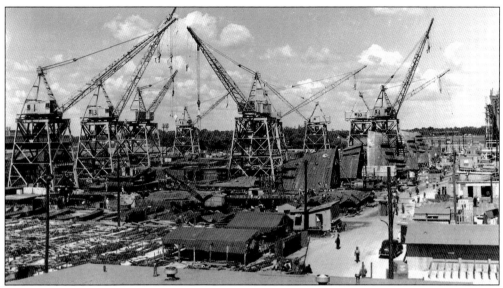

Both workers and administrators at Wainwright hoped that the first ship could be launched on the first anniversary of Pearl Harbor. Due to a lack of time, not diligence, the goal could not be met. The *E. Kirby Smith* was launched on December 30, 1942, by the wife of company president Raymond Jones. On January 9, 1943, the company pledged to deliver 33 ships beyond their original commitment. On February 15, the second ship, *Newton Baker*, was launched, followed by the *John Bascom* and the *William J. Bryan* in April. By July 1944, fifty ships had been launched from the Wainwright shipyard. (BCCC.)

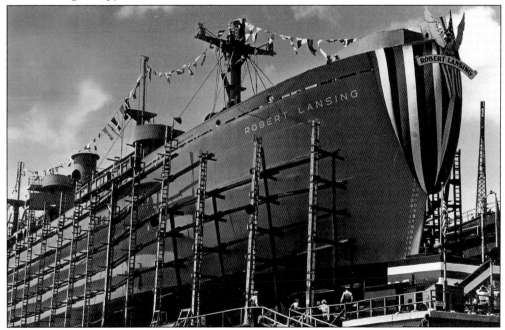

The *Lansing*, seen here dressed for her launch, was only one of the many Liberty ships built in Panama City. Official company records indicate that 66 Liberty ships were built at Wainwright Shipyards. In addition, 8 specialty vessels were built for the transport of tanks and 28 for the transport of boxed aircraft. The last ship was launched in September 1945. (BCCC.)

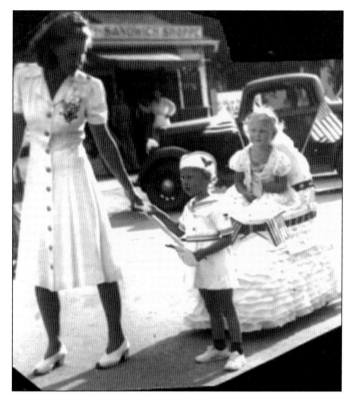

Although the identity of this young mother and her children is not known, there is no doubt that they are part of a rally that took place in Panama City in 1942 to promote the sale of war bonds. With the presence of two military installations and the shipyard in town, Panama City was most active in its home-front support of the war effort. (BCPL.)

The two little girls dressed in patriotic clothing seem to be enjoying the activity of the day. Along with many residents, they are parading down Harrison Avenue in a war bonds parade. The parade may have been the only event of the day, but there may have been more. Nationally known entertainers and musicians made appearances in small towns across America to encourage citizens to support troops by buying war bonds. (BCPL.)

A group of servicemen gathers on a bench outside the Panama City USO building and poses for a picture. With the opening of Tyndall Field in 1941, hundreds of young men arrived in the area. Base housing could not accommodate the number, so many families in the community offered rooms in their homes to them. The dining hall on base had not been completed, so servicemen often enjoyed meals—especially Sunday dinner—with local families. (BCPL.)

In 1944, Jan Colcord was a Bay County High School student who did her civic duty as an aircraft spotter. She was one of several youngsters who spent time after school in this little shelter atop the Dixie Sherman Hotel in downtown Panama City. In the building, there was an aircraft identification poster and a direct phone line to Tyndall Field. If anything questionable appeared in the coastal skies, the spotter would call Tyndall. (BCPL.)

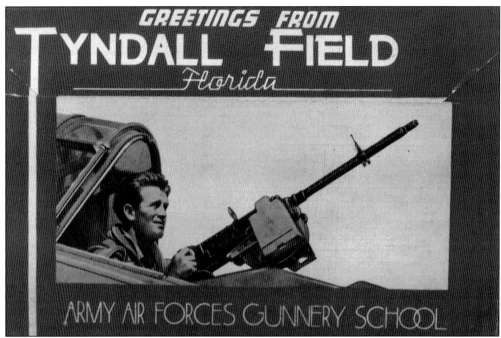

On December 6, 1941, the day before Pearl Harbor, Tyndall Field was dedicated. Its mission was to train gunnery officers. The field was named for a World War I ace flier, 1st Lt. Frank B. Tyndall from Stewart, Florida. In 1947, the field was designated a U.S. Air Force base. Tyndall played a major role in Panama City's economic development and is today an important part of the community. (BCPL.)

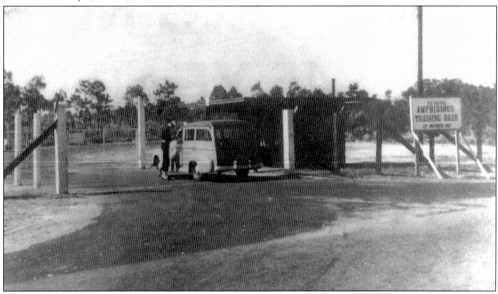

During World War II, the U.S. Navy used a site on the shore of St. Andrews Bay as an amphibious training base. Many who trained there drove landing craft onto the beaches of Europe in 1944. After the war, use of the site changed dramatically. It was announced that the U.S. Navy would locate a technical development and research station in Panama City. Thus, in September 1945, the U.S. Navy Mine Countermeasures Station became a reality. (BCPL.)

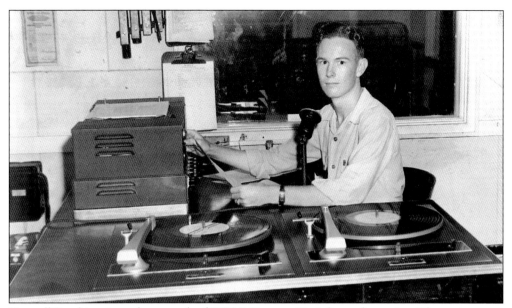

Donnell Brookins sits at the controls of WDLP, Panama City's first radio station. The station went on the air on March 21, 1940. Owner John H. Perry, publisher of the *Panama City News-Herald*, took the call letters from his wife's initials: Dorothy Lilly Perry. The original building was on Beach Drive. Brookins worked first as an announcer and later as station manager at WDLP. His humorous and relaxed manner made him the most sought-after master of ceremonies or promoter on the local scene. (BFC.)

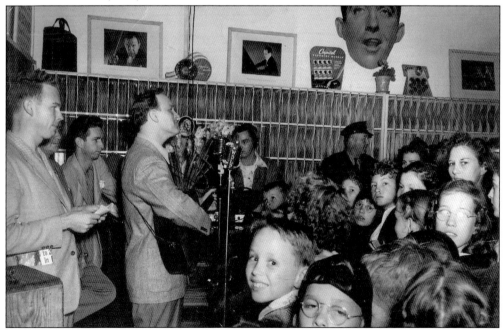

In the studio of WDLP, a singer with a guitar entertains a live audience. There is nothing in the picture to reveal his identity. Locals insist that county singer Eddie Arnold visited the area in the 1940s and claim that he is pictured here. It is certain that Donnell Brookins, seen on the left, is acting as host for the event. (BFC.)

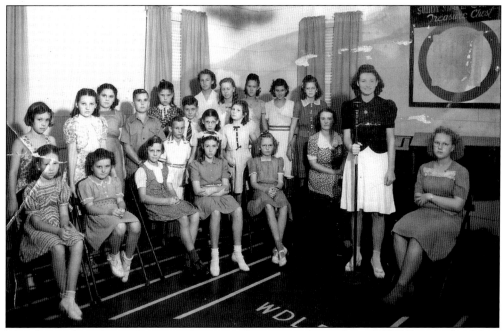

Mrs. Cannon's students of piano and voice made a visit to the studios of WDLP in 1943 or 1944. They performed before the microphone, and their music was broadcast live to the community. Libby Hobbs Tunnell, the tallest young lady in the center of the back row, remembers to this day how scared the children felt to be performing in a studio. (LTC.)

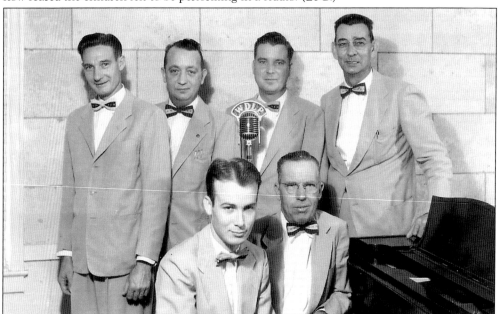

Many residents enjoyed gospel music during the 1940s. The Stamps Union Quartet, pictured here, was one of the most popular groups in town, with a live broadcast each Sunday morning over WDLP. Standing from left to right are Wallace Robinson, Arthur Watson, Grady Courtney (a former city manager) and Cecil Peacock. Seated at the piano are young James Ray Brookins (right) and "Hamp" Hampton (left). (BFC.)

The parade is marching down Harrison Avenue past the newly opened Jitney Jungle Food Store, part of a grand celebration in 1944 marking the event. This store was the first of seven Jitney Jungle supermarkets in the Panama City area. (LFC.)

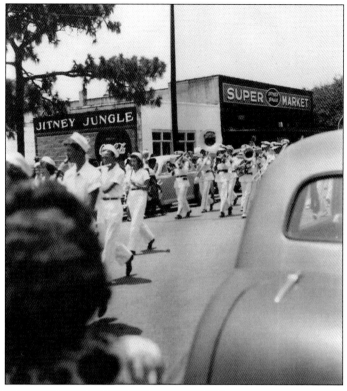

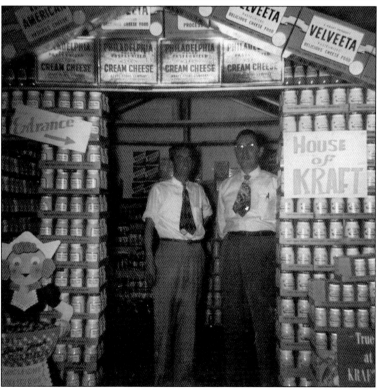

L. D. Lewis is pictured with a representative from the Kraft Foods Company. They are standing in a structure made of Kraft products' containers. It must have gotten a lot of attention. The year is 1950. At that time, store owners like Lewis were closely involved with the day-to-day operation of their business. (LFC.)

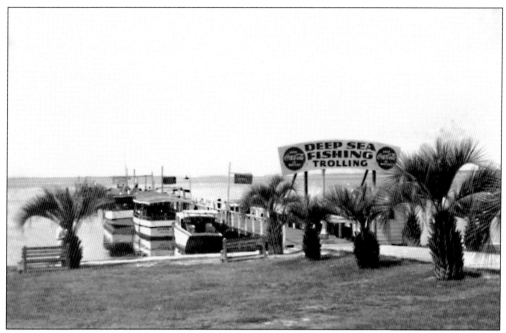

In the early 1930s, this dock located west of the city pier was just the place to book a fishing trip. Tourists coming in on the bay line found they could walk to the Pines Hotel and to the dock from the depot. If they were not interested in fishing, there were boats to take them to the beaches and pavilion at Shell Island. (RCC.)

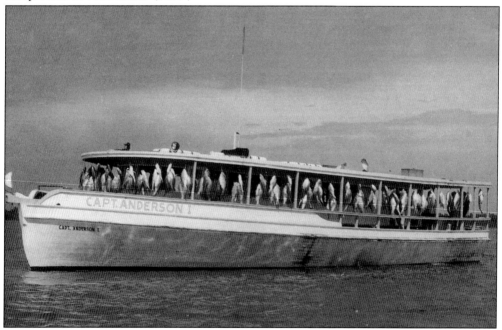

One of the early boats in the C. S. Anderson fishing fleet can be seen here heading for the dock. It was customary to hang the stringers of fish around the boat and display the catch to the crowds gathered on the dock to watch the fleet come in. The boat with the largest catch could always interest some spectator in going fishing the next day. (BCPL.)

In 1959, increased traffic across the old narrow Hathaway Bridge created the need for a new and larger bridge. The structure, composed of steel spans on concrete piers supported by thousands of pilings, was unlike any in the area. Working on the bridge was difficult because of the heights involved. (SFC.)

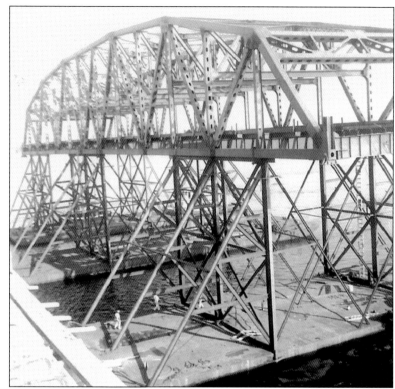

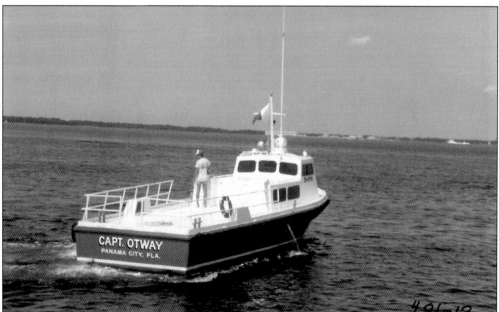

Harbor pilots are trained to guide ships in and out of specific ports. A pilot boat meets the larger vessels in the open sea and puts the pilot aboard with the pilot climbing a rope ladder up the side of the ship. In 1917, there were three pilots and one boat operating out of a station on Hurricane Island. The *Captain Otway*, named to honor an early pilot, Otway Ware, is a more modern version of a pilot boat but is every bit as important. (SFC.)

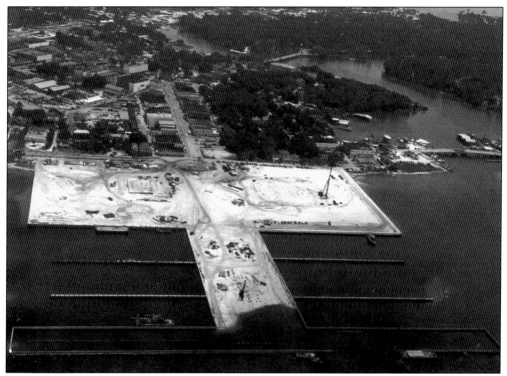

The old city pier was replaced by this massive undertaking in 1957 and completed in early 1959. This aerial photograph shows the outline of filled area upon which the Panama City Marina was being built. On the left is the building that served as the second city hall. The auditorium had not yet been built, nor had the boat docks. (BCCC.)

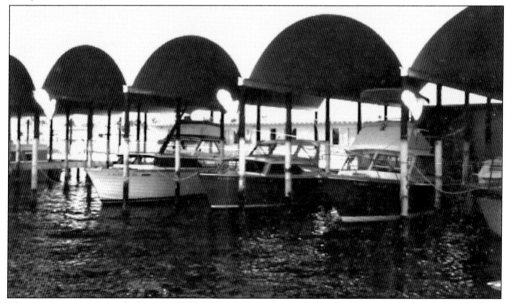

The new marina provided some 400 berths that were available for lease by residents or travelers. Both working boats and pleasure boats were docked here. Observe the vintage craft with wooden hulls. (RCC.)

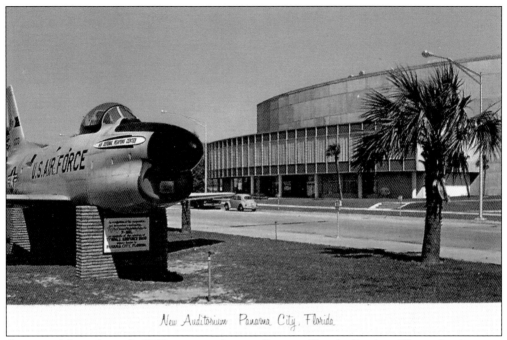

A postcard from the early 1960s pictures the new Panama City Auditorium. The auditorium was a welcome addition to Panama City. It could accommodate large performing troupes as well as an audience of 3,000. The plane displayed in the median was a gift to the city from Tyndall Air Force Base. (AC.)

The Four Winds restaurant and lounge was built on the marina and played host to hundreds of Panama City wedding receptions and other social functions. It was owned and managed by Doug Dick. The popular spot closed when the marina closed for renovations. (BCPL.)

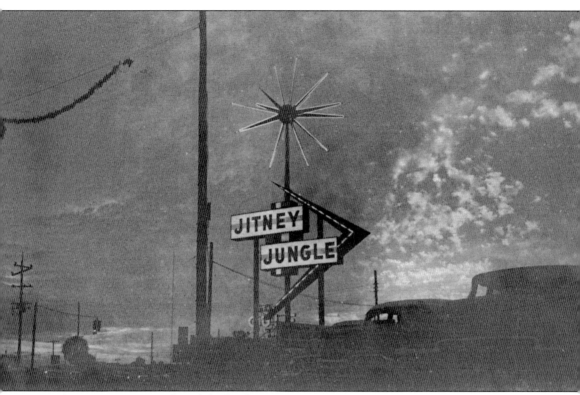

When L. D. Lewis purchased the bright neon sign to mark the location of the Sunshine Food Store at the intersection of Harrison Avenue and Highway 231, he saw it as a representation of the sun and believed its bright rays a perfect way to mark the location of his store. The sphere rotated on its base, and each of its halves revolved as well. The neon lights were in yellows and reds. The sign was installed in 1960. Many residents thought that the sign was a representation of the recently launched Russian orbiter known as Sputnik. It became point of reference when giving directions or a landmark where people met. (LFC.)

Four
COMMUNITY SPIRIT

Capt. Harry Felix recounted in his journal that a party of railroad men came down from the north in search of a terminal for their railway. When one gentleman asked his opinion concerning the desirability of St. Joseph Bay, he said that he "made it plain to him that it was not a desirable harbor." The next day, the men went down to see the bay in George West's launch, the *Lenore*. They were caught in a dreadful storm and had to return overland by mule team. Felix believed "that spell of weather settled the terminal of the Railroad. . . . It was an act of providence in favor of Panama City."

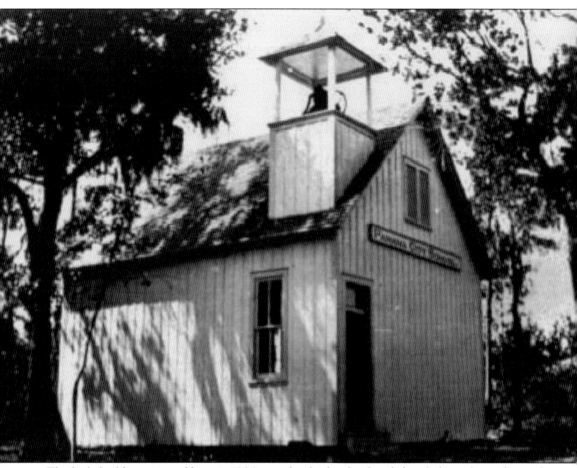

The little building pictured here in 1906 served as both school and church for early residents of Panama City. It was built as the city's first school. There were 33 students enrolled. The one teacher was Frederica R. Payne. Because the population was so small and there were no assigned ministers, all denominations held religious services together; Baptists, Methodists, and Presbyterians united as worshipers. The little school building was their meeting place because there was no community building in town. But as their numbers grew, they began to separate. The Baptist congregation was the first to move into a building of its own in 1910. Then the Methodists found a home of their own, but Presbyterians continued to meet at the school. After Panama City School opened on Seventh Street, the Presbyterians bought the building. With additions for Sunday school rooms, it served as their sanctuary for many years. Today the building is in Bay Memorial Park. (FBC.)

This was the first sanctuary of the First Baptist Church. The frame structure was located on the northeast corner of Fifth Street and Grace Avenue. It was built in 1910. At that time, the pastor was H. S. Howard, who served from September 1909 until June 1911. The parsonage was also located on Grace Avenue. (FBC.)

Rev. W. A. Burns was pastor of the First Baptist Church in Panama City from March 16, 1926, to November 1929. Under his guidance, the congregation moved from the little 1926 church to the stately sanctuary on Harrison Avenue. (FBC.)

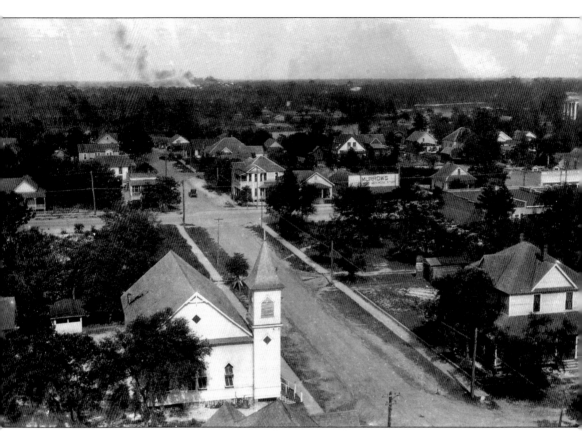

With the addition of the seven-story Dixie Sherman Hotel to the Panama City skyline in 1927, its rooftop became a popular vantage point for photographers. That view was lost when the hotel was imploded in 1970. This photograph, taken in the late 1920s, shows the intersection of Harrison Avenue and Fifth Street looking east. The prominent street running east and west is Fifth Street. The First Baptist Church is on the left, and the parsonage is across the street. To the right, off in the distance, the large multistoried building is the Bay County Court House. Note the cupola on top. It was removed when additions were made to the building. The smoke seen in the distance is from the St. Andrews Bay Lumber Company, located in Millville. (LHC.)

Rev. E. D. McDaniel was pastor of the First Baptist Church from July 1931 until May 1949. He is credited with bringing the church through the difficult days of the Depression. Reverend McDaniel also began to collect and record the history of the church. Here he is pictured with his wife. (SFC.)

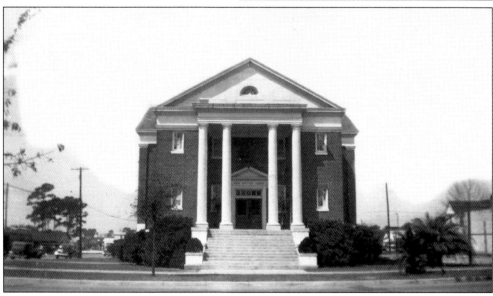

The First Baptist Church of Panama City is seen as it was around 1940. The first service held in the building was a watch night service on December 31, 1926. This sanctuary was used until 1969, when it was demolished to provide a site for a new building. A modern structure with a bell tower replaced it. Over the years, the congregation has continued to grow, and construction is now under way for a larger building at Seventh Street and Harrison Avenue. (FBC.)

On June 10, 1910, the First Methodist Church congregation broke ground for its first sanctuary at the corner of Fourth Street and Magnolia Avenue. Rev. C. J. Butram was pastor at that time. In 1971, this impressive building on Palo Alto Avenue in the Cove neighborhood became the home of the Methodists. (BCPL.)

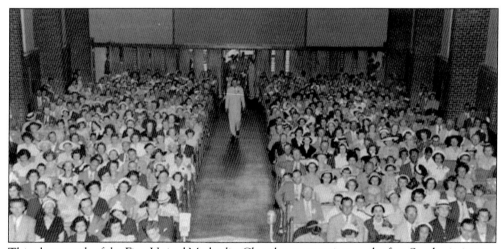

This photograph of the First United Methodist Church congregation on the first Sunday in its new building indicates a packed house. No doubt it was a long-awaited occasion. This location outside of the downtown area has allowed the church to expand as needed over the years. (BCPL.)

About 40 enthusiastic local women met in the Dixie Sherman Hotel dining room to form or perfect an organization dedicated to the beautification of their city in September 1935. Mrs. A. M. Lewis (shown) was elected the first president of the Panama City Garden Club. She served a second term from 1939 to 1941. In 1936, the group joined the Florida Federation of Garden Clubs. They have sponsored beautification projects and educational programs, organized clean-up campaigns and garden therapy programs in Florida prisons, and launched the annual springtime Azalea Trail in Panama City. (PCGC.)

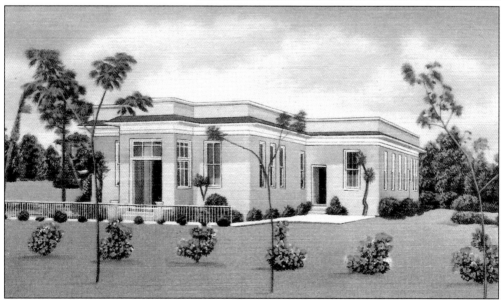

The Wallace Memorial Presbyterian Church building was moved from Harrison Avenue to Bay Memorial Park, where it became the clubhouse for the Panama City Garden Club. Both as a church and as the garden center, this little building has been the site of countless Panama City weddings. (NFC.)

As noted by Mrs. Emory (Louise) Gay Hobbs at the 1967 dedication of the fountain and island in Bay Memorial Park, "It was in the late forties, and the war was over. . . . Ever mindful of the supreme sacrifice that had been made by our servicemen . . . the Panama City Garden Club sought a location to create a memorial to these heroes." In 1947, the city leased to the club approximately 20 acres, and the club transformed the marshes and underbrush into a place of beauty. Bay Memorial Park was dedicated in April 1953. (PCGC.)

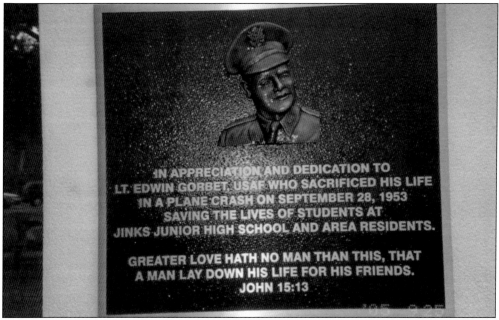

On September 28, 1953, Edwin Gorbet, a 22-year-old Tyndall pilot, lost his life as he tried to avoid Jinks Junior High School after he began experiencing engine trouble. He attempted to guide his plane to St. Andrews Bay but crashed on the grounds of the garden club. On September 26, 2005, the community dedicated a marker to him. It was placed in Bay Memorial Park to remember the sacrifice he made to save the lives of schoolchildren. Many of the students on the playground that morning were at the dedication. (BCPL.)

The Azalea Trail is an annual celebration of Panama City's beautiful azalea blooms. It is sponsored by the garden club each spring. Since 1967, young women in antebellum gowns have competed to serve as the Azalea Queen. After ceremonies on the grounds of Bay Memorial Park Club to crown the queen, a motorcade leads the way along the picturesque trail. Margaret Walters, pictured above in her costume, participated in the event. In addition to the junior- and high school–age young ladies, there is a children's court for boys and girls six to eight years of age. The little ones pictured below from left to right are Lisa Marshall, Lisa Walbridge, and Amy Harrell. (PCGC.)

Card parties were popular among women of the 1960s and even more so if they benefited a particular cause or charity. These ladies are attending a luncheon and card party at the Elk's Club to benefit their Crippled Children's Home. From left to right are Mrs. Sam Morgan, Mrs. Hiram Sperry (wife of General Sperry), Mrs. Vernon Kruse, and Mrs. Ernest Spiva Sr. (SFC.)

The little boys in Sue Lee's scout troop enjoyed a trip to see the workings of Coca-Cola bottling plant and then marched in a local parade. The year was 1951. As best their leader can remember, they include Joe Lee, Bobby Lee, Russell Posey, Carl Anderson, and Bill Pitman. (SLC.)

Each spring, a pioneer picnic is held to gather longtime residents for an afternoon of food and fellowship. The tradition was begun by Judge Ira Hutchison when he hosted the first one at his home. At the present time, the occasion is hosted by the Historical Society of Bay County. Any resident of 50 years or more is considered a pioneer. These picnic participants are probably sharing a story or two. (BCPL.)

Bob Daffin takes a break from an afternoon outdoors to pose for a picture. The little girl is Rachel Legg. He recalls they were kindergarten classmates in 1947. (BCPL.)

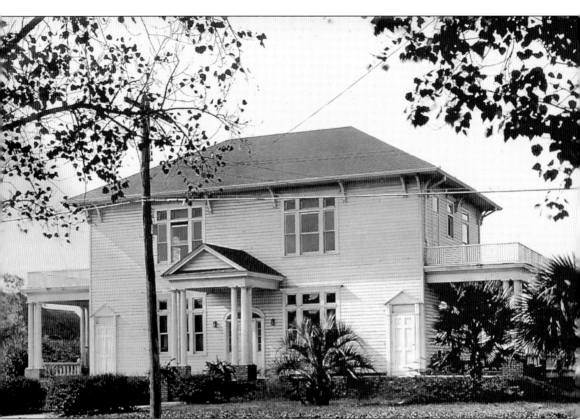

Pictured is the first clubhouse owned by the Panama City Woman's Club. In 1912, Mrs. A. G. Chandlee attended the biennial convention of the General Federation of Woman's Clubs held in California. She returned to her home in Panama City inspired that a woman's club should be organized. Chandlee shared her vision with a number of local women. They held a reception at the home of Dr. and Mrs. J. W. Lee, and the 28 ladies present decided to form a woman's club. On January 30, 1913, at the home Rae Powers, they formally organized and elected officers. Mrs. E. H. Wilkerson became president, and Belle Booth McKenzie vice president. Meetings were held in members' homes until a clubhouse was secured. In 1917, the club was able to purchase this building at 101 Beach Drive for the reduced price of $3,500 from Mr. and Mrs. S. T. Ward. The club was able to raise $2,000, and W. C. Sherman loaned the remaining amount. The large old building presented maintenance problems, and the organization later built a clubhouse in the Old Orchard section of town. (PCWC.)

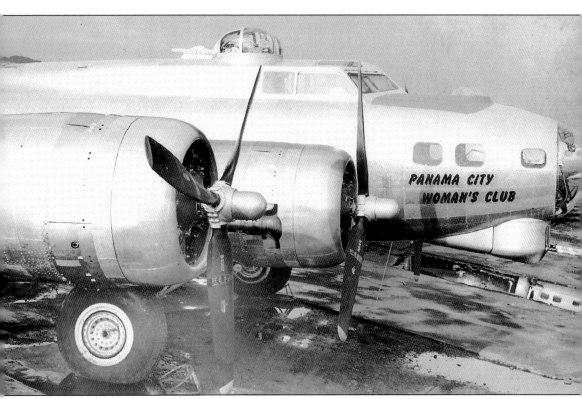

During the war, the woman's club aggressively pushed the sale of war bonds. A letter written to members by Mrs. George Davenport is a witness to their efforts: "Last year the General Federation of Women's Clubs sponsored a Buy-A-Bomber Campaign. Our own local club sold over half a million dollars in War Bonds, and with the other Woman's Clubs in Florida purchased a fleet of twenty-six planes for the army. This year we have the opportunity of showing the same appreciation of the fine work of our men in the navy. The Federation is sponsoring the sale of War Bonds for the purchase of an Air Armada for the United States Navy. We have backed the attack, now let's speed the victory." This B-17 bearing their name is a testament to their success. (PCWC.)

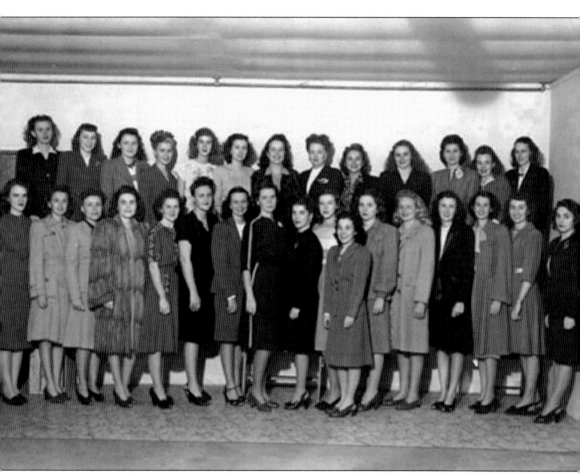

A caption with the photograph of these women recognizes their achievements. It reads: "Woman's Club 'Follies' Class of 1947 celebrates 55 years of community service." The Follies is an amateur musical production put on by the organization to raise money for charitable causes. It brings enjoyment and entertainment to the community. Pictured are, from left to right, (first row) Mable Fleming, Mary Alice Nelson, unidentified, Theola Blackwell, Jean Lewis, Margaret Lewis, Sue Cooper, Louise Lewis, Betty Ann Jeter Smith, Ann Holbrook, "Libba" Byrd, Lorraine Moore, Mary Lou Covington, Pearl O'Shields, Martha Bingham, Dorothy Sue Parker, and JoAnn Pickens; (second row) Ann Cook Humphries, June Gardner, Eloise Smith, Hermina Cowan, Marie Rogers, Lila Nelson, Sara Beth Lokey, Elaine Wiselogel, Del Wood, Mary Ann Crews, Eleanor Lewis, Lucille Kersey, and Jimmy Hutchison. (BFC.)

The clubhouse on Beach Drive was sold to the Elks for $4,500, and the woman's club accepted three lots from developer H. L. Sudduth. The summer of 1936 was spent building a new clubhouse. The architect, James Look, drew the plans and supervised the construction. The total cost for the building was $4,117.50. (PCWC.)

In 1948, Panama City Woman's Club was led by three presidents. Mrs. R. R. Whittington turned the gavel over to Mrs. John A, Stringer, who resigned in November to be replaced by Mrs. Wallace C. Brown for the 1948–1950 terms. Shown from left to right are Grace Wilson (almost hidden), Mrs. E. A. Barrett, Mrs. Edwin Goodhue, Mrs. Bill Guy Sr., Mrs. Wallace Brown, Mrs. George Davenport, Mrs. John Stringer, Mrs. George Compton, Mrs. R. R. Whittington, Mrs. R. L. McKenzie, Mrs. Harry Edwards, Mrs. C. L. Jinks Sr., unidentified, Mrs. L. B. Jeter, and Mrs. M. A. Coleman Sr. (PCWC.)

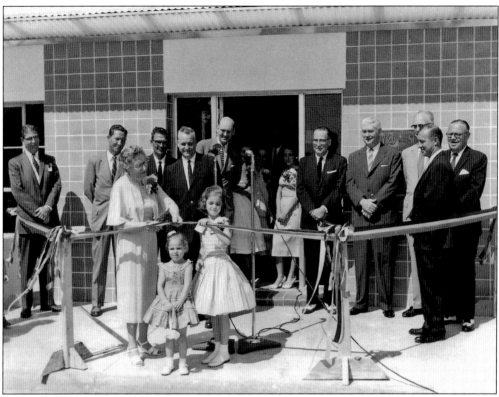

On May 15, 1958, Byrd and Son, the Pepsi Cola bottling plant, had a ribbon-cutting ceremony to dedicate new facilities. Many local dignitaries, friends, and family were present. Mrs. W. O. Byrd, wife of the founder, cuts the ribbon, assisted by Olivia and Betsy Byrd, owner Isaac Byrd's daughters. Isaac Byrd looks on with other family members in the far background. The family pastor, Dr. J. H. Avery, and Mayor Frank Nelson Jr. also took part in the program. (BFC.)

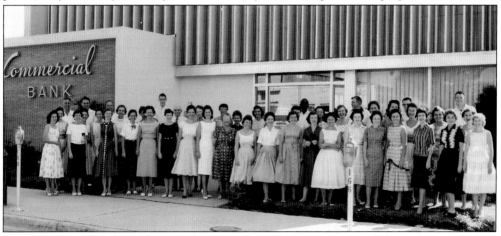

The Commercial Bank, on Harrison Avenue at Seventh Street, was one of the city's more modern buildings. The bank moved from the lower end of Harrison Avenue to this location around 1960 and brought the old clock that had been mounted on the previous building. It could not be mounted on this structure, so it was placed on a pillar at the street corner. Although Commercial Bank is gone, the clock still stands. (NFC.)

L. D. Lewis is serving hot dogs to his customers in one of his supermarkets while product company representatives look on. Lewis was a store owner who talked to shoppers and knew what they wanted and expected in a grocery store. Every Sunshine Store featured a butcher-style meat market and bakery. Many a wedding cake in Panama City came from those bakeries. (LFC.)

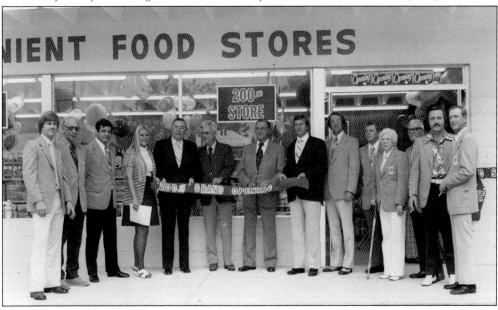

This ribbon-cutting ceremony celebrates the opening of the 200th Jr. Food Store. The year was 1971. Pictured from left to right are Clay Smith, Jerry Castardo, Lana Jane Lewis-Brent, L. D. "Sunshine" Lewis, Don McCoy, Isaac Byrd, and Jimmy Lewis. The Jr. Food Store changed shopping in Panama City, because basic items were available close to home, and shoppers could quickly shop for a single item. (LFC.)

The Spring Arts Festival serves as a fund-raiser for the many community service projects of its sponsor, the Junior Service League. The festival began in McKenzie Park over 40 years ago. Crowds are an indication of its popularity. It is a venue for regional and local artisans and craftsmen to sell their work and an opportunity for residents to acquire unique pieces. (BCPL.)

As an observation of Arbor Day and in the spirit of community improvement, the Bay County Chamber of Commerce provided packages of seedlings to residents interested in planting them. Ted Haney, president of the chamber in 1987, is shown handing out the tree bundles in downtown Panama City. (BCCC.)

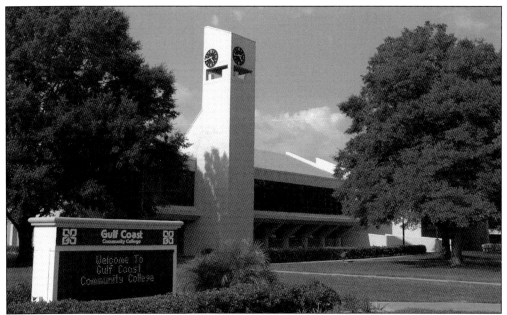

Gulf Coast Community College held its first day of classes on September 17, 1957. Only 439 students were enrolled, and 12 faculty members were employed. Its greatest offering to residents of the city and rural areas beyond was opportunity. With the opening of a junior college, it was possible to earn an associate degree without leaving the community. Those who worked to establish the junior college then turned their efforts to securing a university branch campus that would enable students to earn a bachelor's degree locally. (GCCC.)

Sally Stevenson watches as her daughter Elizabeth and son Billy share their peanuts with each other and maybe the fish. The children are sitting on the Watson Bayou dock of Bay Marine and Propeller Company where their father, George Stevenson, worked. The picture was made in the early 1960s. (WSC.)

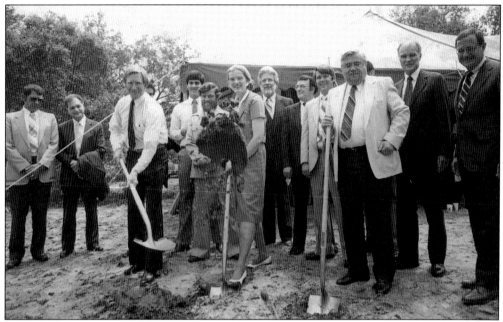

Ground was broken for the permanent campus of Florida State University–Panama City in 1984. Lifting shovels from left to right are state senator Dempsey Barron; Dr. Barbara Newell, chancellor; and Dr. Bernard Sliger, president of Florida State University. In the background at far left is school superintendent Pete Holman; on the left behind Dr. Sliger is John Hutt, and on the right is Mayor Girard Clemmons. (BCPL.)

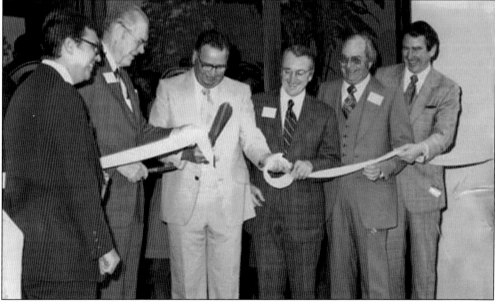

Here the ribbon is cut to signify that the new Gulf Coast Community Hospital is open. Shown from left to right are H. Philip Gibb, administrator; Dr. Thomas Frist Sr., founder and president of Hospital Corporation of America; Panama City mayor M. B. Miller; Dr. Dixon McCloy, chief of physicians; Dr. James Poyner, member of the board of directors; and Dr. Thomas Frist Jr., vice president of Hospital Corporation of America. The date was January 2, 1977. (BCPL.)

A souvenir of Panama City's diamond jubilee, this program cover marks the date as March 9, 1984. It was a day of activities reminiscent of the early days, when residents gathered downtown to celebrate special occasions. Speakers recalled life in earlier days and gave a history lesson to the young. (BCPL.)

SEVENTY-FIFTH ANNIVERSARY DIAMOND JUBILEE

PROGRAM

MARCH 9, 1984

CARAVAN OF ANTIQUE CARS 3:30 P.M.
 (From Panama City Mall to City Marina)

FLY-OVER .. 3:45 P.M.
 (Tyndall Aircraft)

INVOCATION ... 4:00 P.M.
 (Reverend Si Mathison)

NATIONAL ANTHEM
 (Emporium Four Barber Shop Quartet)

RECOGNITION OF DIGNITARIES
 (Mayor Girard L. Clemons, Jr.)

REMEMBERING OLD PANAMA CITY
 (M. G. Nelson)

PANAMA CITY HISTORY
 (Tommy Smith)

MEDLEY OF SONGS
 (Emporium Four Barber Shop Quartet)

PRESENTATION OF SPECIAL AWARDS
 (Mrs. Herbert Etheridge)

CUTTING OF BIRTHDAY CAKE
 (Mayor and Mrs. Clemons)

A full day of activities were planned to celebrate the 75th anniversary of Panama City's incorporation. It began with an antique car parade down Harrison Avenue. Planes from Tyndall saluted the city with a flyover. Music was plentiful, and so was birthday cake. Mayor Girard Clemmons and his wife, Barbara, presided over the festivities. (BCPL.)

Five
LOOKING TO THE FUTURE

Panama City will celebrate its 100th birthday on February 23, 2009. With centennial events already under way, we enjoy looking at photographs that remind us of how far we have come. The pioneers of Panama City were right when they saw that nature had dealt kindly with this place and decided to make their homes here. Pictures of days long gone can bring back memories of those settlers and their accomplishments. Now it is time to recognize the recent events that are part of our history. Let us browse pictures of those events and evaluate our accomplishments. In the years to come, that is what our children and grandchildren will be doing. Perhaps we may glimpse the future in these photographs.

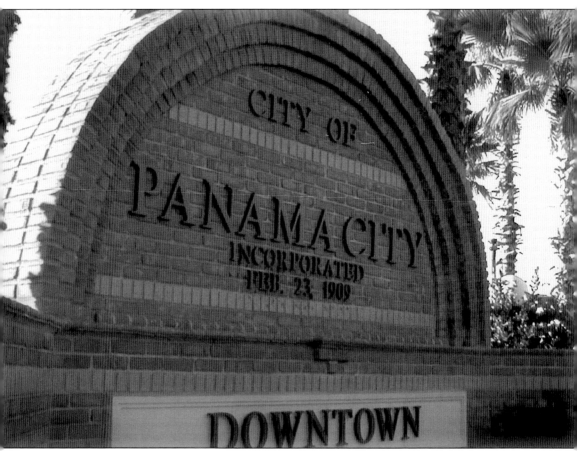

These handsome brick city gates welcome residents and visitors alike to downtown Panama City. They are located on either side of the Harrison Avenue and Seventh Street intersection. Seasonal flower beds at the base of the markers add color to the scene. From this point south to the marina at the end of Harrison Avenue, the rather dreary storefronts of the late 1970s have changed their faces. A number of professional firms have located offices in the downtown area. After successful renovations to most buildings and storefronts, the city has evolved into an attractive destination. A number of cultural events and festivals are held on the street during the year. The seven blocks of specialty shops, restaurants, art galleries, the Martin Theater, and the civic center await visitors. (DIB.)

Today the appearance of Harrison Avenue is softened by effective landscaping and attractive lighting. It seems to beckon the pedestrian shopper. The shade offers shelter from the sun and the heat buildup of concrete sidewalks. The lampposts are often decorated with banners of welcome or reminders of seasonal events in town. At Christmas, the holly wreaths with large red bows around the lights set the tone for a traditional celebration. (DIB.)

The new sidewalks feature a design in brick pavers that is more attractive and cooler than plain concrete. The addition of benches and seating areas give the weary shopper a place to rest. Awnings over store fronts and windows offer protection from the sun and showers. (DIB.)

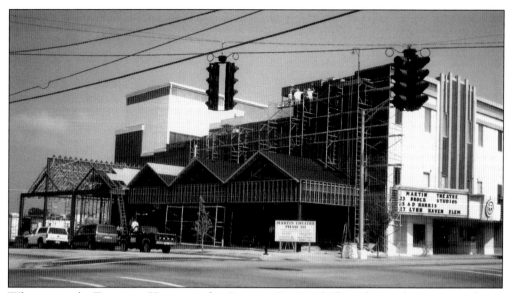

Where once the Tennessee House stood in Panama City's early days, this modern room with two outside walls of glass now nestles between attractive landscaping and the Martin Theater. The Tennessee House was demolished mid-century and replaced by Schneider's department store. That building was razed, and in its place was built this new structure, known as the Green Room, possibly the most popular venue in Panama City for entertaining. (DIB.)

Built by W. C. Sherman in the 1930s, the Sherman Arcade first housed retail outlets on the ground floor and offices above. The open courtyard in the center with a huge skylight above provided light even when electricity was less than dependable. By the 1960s and 1970s, its tenants had moved elsewhere, and it had become one of the most unattractive buildings in town. Today it is a prime example of successful restoration and, according to some, the most attractive structure downtown. (DIB.)

The Sherman Arcade was gutted but restored to its original design. The open center was preserved, as was the skylight. The decorative ironwork on the face of the building was restored. By use of research and memory, the color was closely matched to the original. (DIB.)

The transformation of the Sherman Arcade from its appearance in 1975 to this view today is one of the most pleasing on Harrison Avenue. Four attractive apartments on the upper floors offer a home for the true urban resident. Again retailers, a café, and dress shops occupy the ground floor. The courtyard next to the building leads to McKenzie Park. (AC.)

Members of the McKenzie family celebrate the release of a compact disc of Christmas music that they recorded. The younger McKenzie generation carries on the musical talent of their early family. Shown here standing on a balcony above the front porch of the McKenzie House from left to right are Greg, Laura, Alyssa, Cathy, Anne, Barbara, Jill, and Jan. (BCPL.)

The McKenzie House opens its doors to holiday shoppers on Friday nights between Thanksgiving and Christmas. In conjunction with the McKenzie Foundation, the Historical Society of Bay County offers home tours, horse-drawn carriage rides, and entertainment. Young ladies in period costume greet guests and pass out candy canes. Here Greenlee Ann Walters takes a break from her duties. (AC.)

The first Friday evening of each month from April to November, downtown is the place to be as the Downtown Improvement Board hosts Friday Fest. From Sixth Street to the marina, Harrison Avenue is closed to traffic, and vendors lease space along the street to display and sell their merchandise. Musical groups are set up at several intersections and provide entertainment. Food vendors offer everything from seafood to sausage dogs. Crowds stroll along, eat, meet friends, socialize, listen to music, and enjoy being outdoors. (DIB.)

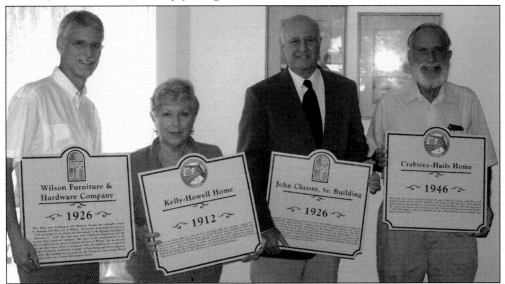

Historical markers placed on old buildings stimulate interest and appreciation, educating the public and encouraging preservation of the old structures within the city. The Historical Society of Bay County is assisting owners with research and stressing the importance of placing markers on historically significant sites. Here recipients are presented their markers. From left to right are Rob Koehnemann, Ruth Howell Hauser, George Christo, and Tom Hails. (AC.)

Larson M. Bland served as the first dean of the Florida State University–Panama City campus until his retirement. His friends honored him and recognized his accomplishments in that position by funding an endowed scholarship in his and his wife's name. Dr. Bland is seen in the center accepting the award from Leon Walters. On his right is his wife, Beverly, and partially visible is Dean Ed Wright. Dr. Ken Shaw, assistant dean, is seated in the back. (AC.)

Construction on the campus today is the most visible evidence of the growth that the Panama City campus of Florida State University has experienced. Enrollment continues to grow, and 10 undergraduate and a number of graduate degree programs are currently offered with more added each year. (AC.)

Local artists designed and decorated these life-size fiberglass figures to be auctioned for charity. Imagination and talent ran wild, and the designs ranged from humorous to realistic. Prior to their auction, the decorated dolphins were displayed along Harrison Avenue. Here a pod swims in front of the Surplus Sales store. A number of the dolphins are still displayed for the community's enjoyment in several public places. (DIB.)

Library employees pose for a group photograph after looking over the plans for a new facility. They have outgrown their present building and expect to move into their new accommodations in the spring of 2008. The new 18,000-square-foot building will be located on Eleventh Street. (BCPL.)

On May 10, 2004, an official ribbon-cutting ceremony to celebrate the opening of the Hathaway Bridge was held. A part of that impressive ceremony, held as the traffic sped across the span, was recorded in this photograph. On the left are a group of ambassadors from the chamber of commerce. The first man on the left, holding the ribbon, is Florida Transportation Commission chairman Earl Durden. Speaker of the Florida House Allan Bense is next in line followed by, from left to right, Elizabeth Walters, chair of the Bay County Chamber of Commerce; Edward Prescott, Florida Department of Transportation District 3 secretary; Debra Hunt, chair of Panama City Beaches Chamber of Commerce; and Rev. Si Mathison, who gave the invocation. Tom Boyle of Granite Construction also spoke briefly to the crowd. Lunch for everyone in attendance was provided by Granite Construction, the primary contractors for the project. (AC.)

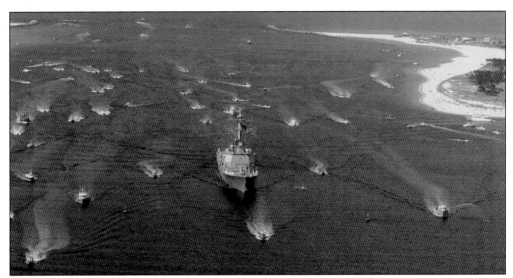

Welcomed by dozens of private boats and hundreds of spectators along the shoreline, the navy destroyer *Momsen* made its way into Port Panama City on August 20, 2004. Panama City residents hosted events for crew members leading up to the commissioning of the *Momsen*. Its crew of 350 men and women spent the next 11 days making preparations for the commissioning, but they reciprocated the city's hospitality by giving time to local charities. On Saturday, August 28, over 6,000 residents attended the ceremony despite the scorching temperatures. It was one of the most important military events ever to take place in this area. The *Momsen* had a special link to Panama City long before its arrival. The navy selected its name to honor Vice Adm. Charles Bowers "Swede" Momsen. He invented a submarine rescue device known as the Momsen Lung. He also led the rescue effort for the USS *Squalus*, which sank in the North Atlantic in 1939. Thirty-three people were saved in that rescue. The commissioning of the *Momsen* was so successful that the U.S. Navy is planning to commission another ship, the *Mesa Verde*, in Panama City on December 15, 2008. (AC.)

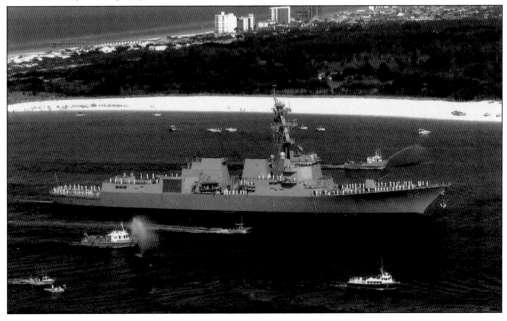

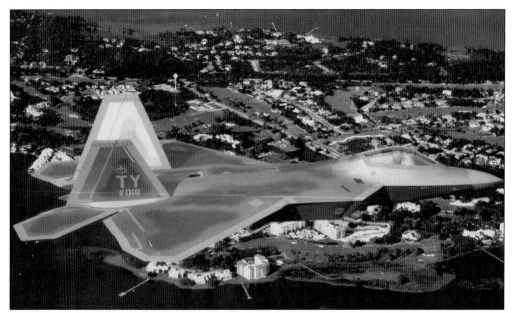

Panama City has held a unique relationship with both the U.S. Navy and the U.S. Air Force since their arrival during World War II. Both of the military bases bring community-spirited families into the area. The F-22 Raptor, pictured here, is the latest addition to the U.S. Air Force line up of fighters. Pilots selected to fly them will be trained at Tyndall Air Force Base. (AC.)

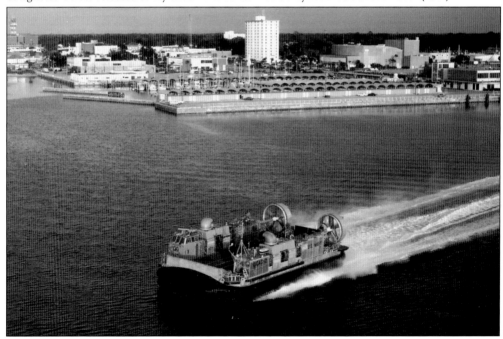

On maneuvers in the water off the city marina is a navy hovercraft known as an LCAC (Landing Craft Air Cushion). These craft are for transporting men and equipment from large amphibious ships at sea to landing areas on the beach. Engineers and scientists at the navy laboratory in Panama City led the way for the development and testing of these craft, which are necessary for landing operations of the U.S. Marines. (AC.)

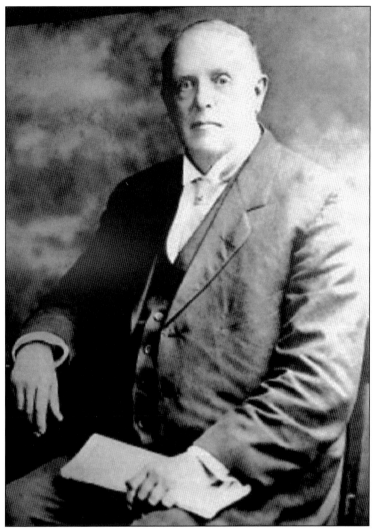

The vision of the Panama City Centennial Committee is to create a magnificent celebration of the city's 100th birthday reflecting the diversity and uniqueness of the city. Their mission is to honor the past, celebrate the present, and imagine the future. Organized in October 2006 under the chairmanship of Rebecca Saunders, the committee has stated its mission and set goals for its fulfillment. To celebrate and commemorate the city's history is foremost, but the committee must educate, involve, and inspire the community in that history. They intend to create opportunities for a wide range of citizens, organizations, and businesses to participate. They hope to draw residents and visitors to the major centennial events. The Centennial Committee has also committed itself to leaving a legacy for future generations. Creating a permanent museum of local history for the city and its surrounding communities is their goal. In addition, committee member Dr. Mark Mulligan has submitted plans for a historical monument honoring the city's founder, George Mortimer West, and the citizens who held the office of mayor during this initial century. The circular monument will encourage viewers to walk around its perimeter to see portraits of these individuals and read a brief biography of each. The portraits will be cast on panels of marble like the one above George West. The Panama City Centennial Committee voted to support and work for the erection of this memorial in time for the celebration on February 23, 2009. (Courtesy of Dr. Mark Mulligan.)

Discover Thousands of Local History Books
Featuring Millions of Vintage Images

Arcadia Publishing, the leading local history publisher in the United States, is committed to making history accessible and meaningful through publishing books that celebrate and preserve the heritage of America's people and places.

Find more books like this at
www.arcadiapublishing.com

Search for your hometown history, your old stomping grounds, and even your favorite sports team.

Consistent with our mission to preserve history on a local level, this book was printed in South Carolina on American-made paper and manufactured entirely in the United States. Products carrying the accredited Forest Stewardship Council (FSC) label are printed on 100 percent FSC-certified paper.